Look and Leave

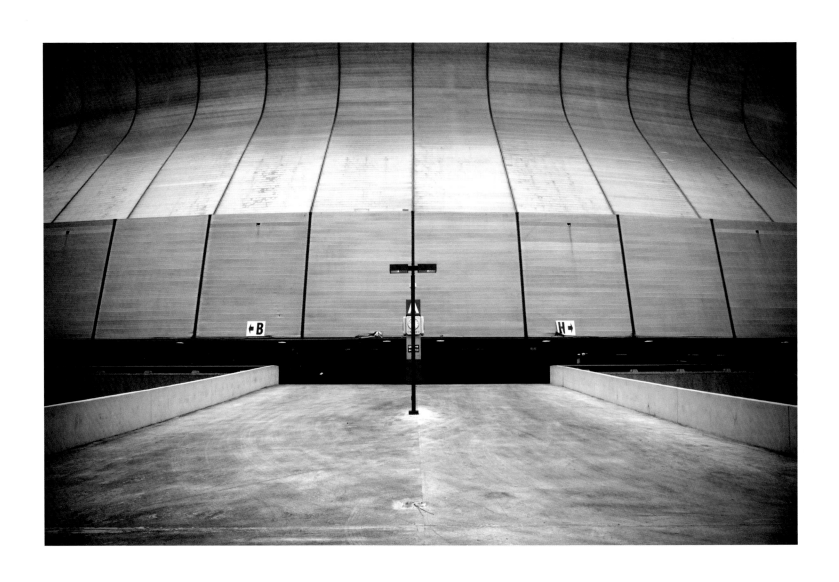

The Louisiana Superdome, during the cleanup following Hurricane Katrina, November 7, 2005.

Look and Leave

Photographs and Stories from New Orleans's Lower Ninth Ward

by Jane Fulton Alt
Introduction by Michael A. Weinstein

Center Books on the American South
George F. Thompson, series founder and director

The Center for American Places
at Columbia College Chicago

The Center for American Places at Columbia College Chicago
600 South Michigan Avenue
Chicago, Illinois 60605-1996, U.S.A.
www.americanplaces.org

Distributed by the University of Georgia Press
www.ugapress.uga.edu

17 16 15 14 13 12 11 10 09 5 4 3 2 1

Library of Congress Cataloging-in-Publication Data

Alt, Jane Fulton, 1951-
Look and leave : photographs and stories from New Orleans's Lower Ninth Ward / Jane
Fulton Alt ; with an essay by Michael A. Weinstein. — 1st ed.

 p. cm.

 ISBN 978-1-930066-90-8 (hardcover) — ISBN 978-1-930066-91-5 (pbk.)

 1. Lower Ninth Ward (New Orleans, La.)—Pictorial works. 2. New Orleans (La.)—
Pictorial works. 3. Hurricane damage—Louisiana—New Orleans—Pictorial works. 4.
Hurricane Katrina, 2005—Social aspects—Louisiana—New Orleans—Pictorial works.
5. Community life—Louisiana—New Orleans—Pictorial works. 6. African Americans—
Louisiana—New Orleans—Pictorial works. I. Weinstein, Michael A. II. Title.

 F379.N562.L693 2009

 976.3'350976335—dc22

 2008045089.

ISBN 13: 978-1-930066-90-8 (hardcover)
ISBN 13: 978-1-930066-91-5 (paperback)

The epigraph on page v is from an interview with Anne Rice,
"10 Questions," in Time (March 17, 2008), page 6.

To the residents of the Lower Ninth Ward of New Orleans

"New Orleans has a way of triumphing, no matter what happens.
There is an unstoppable spirit in the people there."

Anne Rice, 2008

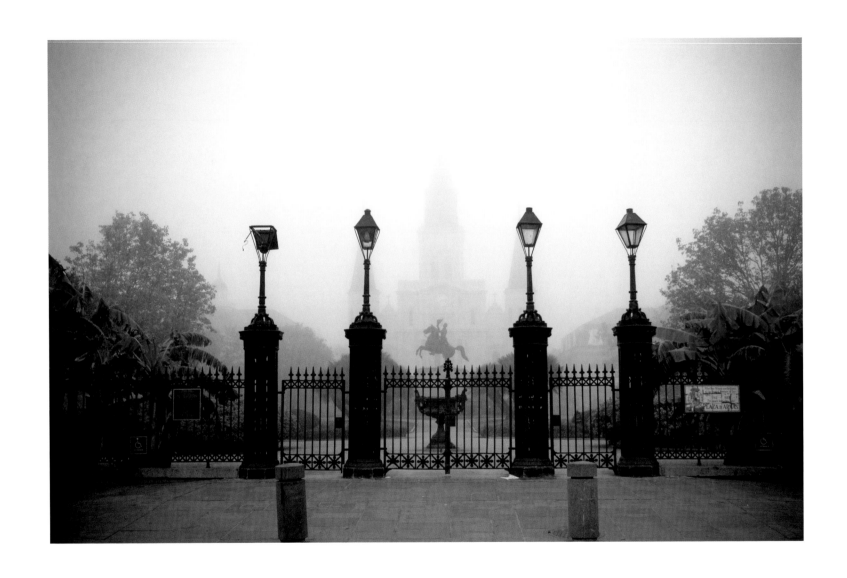

Jackson Square, the New Orleans that visitors come to see, November 8, 2005.

Contents

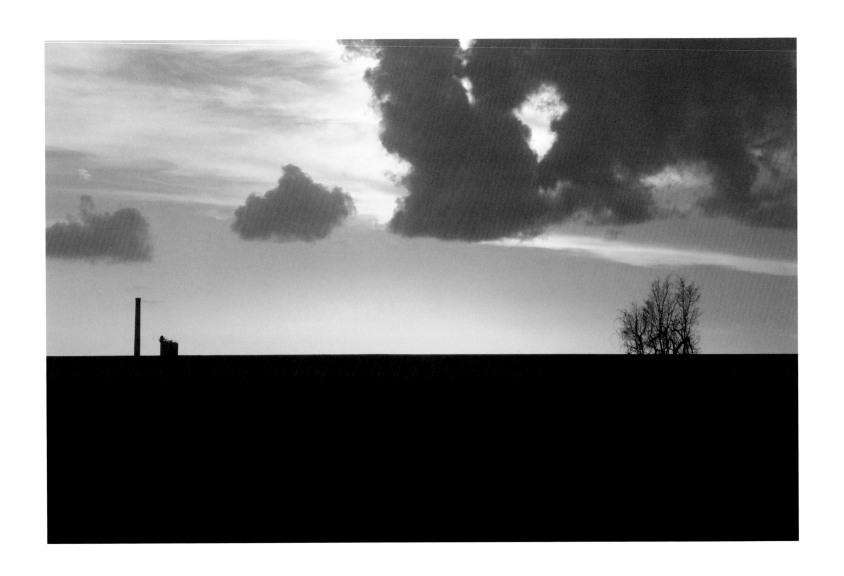

Dusk along the Industrial Canal, September 23, 2006.

Preface

As a photographer, I prefer to let pictures speak for themselves. But, as a social worker, I know that there are some images that stories can illuminate. What I witnessed in the Lower Ninth Ward of New Orleans in November of 2005 is only a small chapter of a much larger story that is still unfolding. The photographs contained in this book are reflections of my exposure to the aftermath of one of the worst disasters ever to occur in the United States of America. The following accounts are just a few of the many my teammates and I heard and experienced while serving in New Orleans.

Like all who watched the tragedy of human suffering unfold for days on end following Hurricane Katrina, I felt a profound sense of helplessness. This feeling led me to volunteer my skills as a clinical social worker. I had no idea how my expertise would be used. All I knew is that I would be on a team of sixteen mental health professionals from across the nation. I left Chicago feeling some excitement, a little anxiety, and a lot of anticipation.

I was assigned to a program called "Look and Leave" organized by the City of New Orleans. The program was designed to provide the evacuated residents of the Lower Ninth Ward, then scattered over forty-eight states, with an opportunity to return and view their homes for the first time since they fled the storm. All of the residents were returning for the first time, many for the last time. They came at their own expense from as far away as California, Florida, Illinois, Indiana, Mississippi, Montana, and New York. Since almost no lodging was available, many of the residents could spend only one day in the New Orleans area. Immediately following our brief orientation, members of the mental health team accompanied the residents on the buses into the devastated neighborhoods.

Following Katrina, most people were not allowed back into their homes. Mud, mold, toxic contaminants, and the houses' unsound structures made it dangerous to enter. While accompanying residents on the bus trips, I felt as if I was part of a family going to view the remains of a loved one for the first time. One team member commented, "This is the longest funeral I have ever attended."

The emotional climate on each bus ride was different. Some trips were made in somber silence. On other trips the residents were busy trying to put the puzzle back together: "Where did the Robinson's house go?" "What hap-

pened to Miss Lacy's house?" One man, with a sense of humor, asked the bus driver to stop so he could recover one item from his property . . . the Brinks Protection sign standing on his front lawn! A chorus of laughter followed. I heard the word "gone" repeated over and over. I also heard quiet singing, perhaps the beginnings of new gospel hymns.

By the end of my first day serving on the "Look and Leave" program and viewing the remains of the devastated community, I felt physically ill. Following three days and seven bus trips, I had an unrelenting "Katrina cough" along with a pounding headache. The physical and emotional fatigue was so pervasive that I had to leave the site. This was a turning point for me. Within an hour of returning to the hotel room, something within me shifted and I knew I needed to do more I decided to photograph what I was seeing, with the hope of helping in a more concrete way by giving others visual access to my experiences.

On the last night of my first trip to New Orleans, there was discussion with members of the relief team about how we might be ambassadors for the people we served by keeping their stories alive and their needs in focus. The photographs in this book are the culmination of my ongoing efforts to describe what I witnessed during those two weeks in November 2005 and my subsequent trips back to the Lower Ninth Ward in June and September 2006 and February 2007.

Our natural instinct is to try to generalize any experience. To do so about my post-Katrina experience would be unfair to us all. During the time I spent in the Lower Ninth Ward, I encountered feelings of frustration, anger, fear, helplessness, shock, despair, hope, optimism and love, both my own and those of the residents. The best and worst of humankind were revealed, as it often is in such extreme situations. I saw people looking to profit from the misfortunes of others and people who showed boundless generosity toward complete strangers.

I was privileged to be with families at an intimate and critical time, a time when daily concerns receded and what was most vital rose to the top. I learned so much from the people I worked with. Their strong sense of faith sustained many. But, most importantly I learned that what is essential in life is not where we live, where we work, what we own, or how much money we make, but how well we love and treat one another.

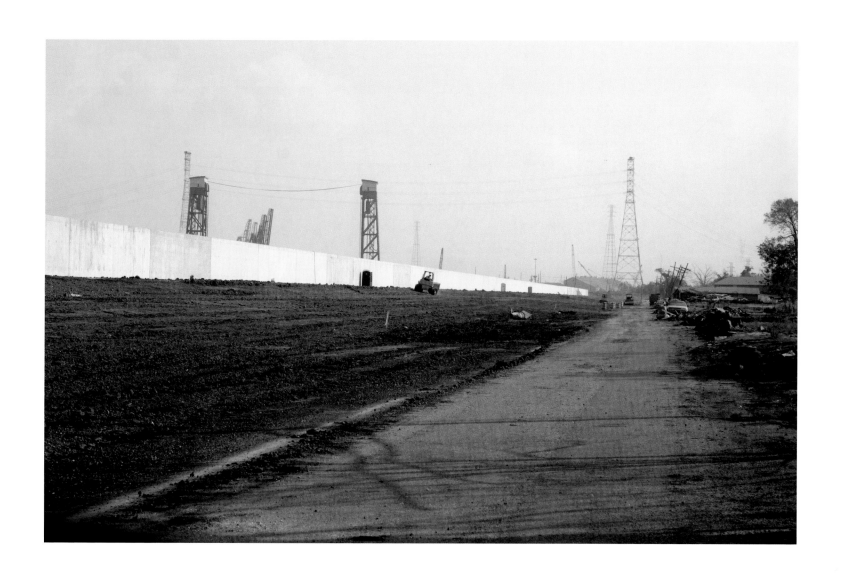

Rebuilding the Industrial Canal, June 14, 2006.

Look and Leave

The Emotive Document

by Michael A. Weinstein

In our technological age in which control over fortune seems almost to be within our grasp, we are reminded with increasing frequency that nature continues to hold the upper hand, snapping lives apart in catastrophic moments. Such a moment came on August 29, 2005, when Hurricane Katrina made landfall off the Gulf Coast of the United States, despoiling communities and, along with them, our vanity, as the storm carved its path of destruction.

As she watched the images of the storm flicker across the television screen from the safety of her home in Evanston, Illinois, Jane Fulton Alt reports that she felt "helpless." Gifted with a deep sensitivity and a keen critical intelligence, Alt was no stranger to the extremities of the human condition, which at their devastating pole reveal our fragility. As a clinical social worker, she had chosen a life devoted to helping others in distress. But, rather than becoming case-hardened over the years, her compassion and wisdom had become ever more intense and finely honed.

Yet Katrina had a particularly profound impact on Alt. She was not content to feel the despair from a distance, and she was incapable of lapsing into voyeurism. She had to do whatever she could to ameliorate the suffering of the storm's victims.

Alt's path to participating in relief was to volunteer as a social worker in the "Look and Leave" program, which gave an opportunity to the scattered residents of New Orleans's devastated Lower Ninth Ward to revisit their ruined homes for a single day.

If we have lived long enough, we can understand the healing impulse behind coming back to the site of a personal disaster. The philosopher and psychologist William James noted that there is a material dimension to our selves that extends into our environments: our clothing, our home, our furniture, and our personal possessions—prized, humble, and often both—are as integral to us as our bodies, feelings, thoughts, and, as James also understood, our loved ones. The pang of loss and the searing sense of violation that we experience even when a garment rips or a cup shatters is magnified into a trauma when we lose our home and everything in it. Whether the loss is irretrievable or might in the future be reversed by restoration or relocation we often desire one more look at the ruin so that we can come to terms with it, grieve over it, and crystallize our memories.

In committing herself to be there for the mostly poor African Americans whose material selves had been shattered by the storm as they underwent the complex and painful, yet potentially lib-

erating, experience of revisiting, Alt was drawn into empathy with them. Most of all, she felt a keen sense of solidarity with them that led her to a personal encounter with the ruins that she had not anticipated. It was then that another dimension of herself—the photographic artist—became manifest, and she needed to do her own revisiting with a camera so that she could do whatever was in her power to perpetuate the memory of the victims and their loss.

Understanding the genesis of Alt's series of color images of the ruins of the Lower Ninth Ward makes it difficult to consider them strictly from the standpoint of photographic art. Yet Alt invites, indeed constrains us, to do just that, because she is as much a masterful photographer as she is a compassionate social worker, and, in her own inward life, her two public sides interpenetrate and function symbolically.

Looked into as photographs, Alt's images are documents of ruins. The documentary genre covers a range, which, at one end, is evinced by photographs intended simply to record precisely an object or event and, at the other end, by photographs meant to sublimate their subjects into images for aesthetic contemplation that at the farthest limit are transmuted into abstractions in which concern for their subjects is altogether eliminated. Choosing ruins as the subject of the document has its own special range of options that originate from the romantic tradition of "redeeming the ruins"—a phrase of Aaron Siskind—to emphasizing their negativity brutally.

Alt's images of the Lower Ninth Ward in the aftermath of Hurricane Katrina do not fit neatly into any of the traditional categories, nor do they fall between the extremes. Although she has an exquisite compositional eye that does not allow her to produce images that lack formal elegance, Alt rarely enters the territory of abstraction, nor does she glory in the ruins romantically. Yet she also does not stand apart from her subjects dispassionately and ruthlessly record spoliation. Her images, finally, are integral and do not communicate a tension between the impulses to aestheticize and record.

Alt works on a different plane and dimension from the ones in which conventional alternatives operate. She has produced emotive documents that place us with her when she pressed the shutter release and give us the opportunity to experience as she did, if we are willing to respond to her images fully and freely. We are invited neither to look through Alt's photographs to their subjects nor to look at them as self-standing images, but to inhabit them. When we do so, we discover a dense complexity that is remarkably true to the nuances of our concrete, lived experience—beauty and ugliness, rays of hope and clouds of despair, redemption and brutality— none of them in tension and at odds with each other, all of them together, as they are at every mo-

ment of our lives, which is something that we acknowledge only in our moments of heightened sensitivity.

The complex emotions that are released in us when we dwell in Alt's photographs mirror the responses that she observed in the people whom she accompanied in the "Look and Leave" program and then experienced for herself in follow-up visits. If we are attuned to these images, it is inevitable that they will evoke in us reflections on times when parts of our own material selves were devastated and destroyed—how we grieved and remembered, how we loved and raged and sorrowed and even laughed with irony. By giving way to a personal response, we become solidary with the people of the Lower Ninth Ward which is what Alt asks from us.

According to convention, an essay to a book of photographs should contain descriptions of some of the images in order to build a bridge to them for the viewer and to all the others. Indeed, it is a staple of modern photographic criticism that images by themselves are incapable of revealing their import and need to be supplemented with lengthy captions or notes on the photographs. Yet Alt tells us that she prefers "to let pictures speak for themselves," and I will honor that preference with the caveat that one will be unable to receive the full gift of her emotive documents unless one participates in them and overcomes any resistance to responding personally to them.

Alt also relates that she only photographed places and not people out of respect for the residents' privacy, which is doubtlessly true, yet her choice cuts much deeper than that. She wants us to see as the people of the Lower Ninth Ward did and, through identification, as she did, at ground level as they contemplated their rended material selves, often in fine detail, by creating an intimacy with her subjects. We are invited to partake in that intimacy and to use it as an occasion for association.

When I visited the exhibition of Alt's photographs of New Orleans at the DePaul University Art Museum in 2006, I spent an entire afternoon there, longer than I have spent at any exhibition before or since. Her images worked on me as she intended, and I found it difficult to pull myself away from them. They haunted me for days afterwards, taking me back to times when parts of my material self had been wrecked and ruined, reminding me of the day several weeks after I had totalled my car in an accident that had resulted in a serious injury to a loved one, when I felt an urgent need to revisit the wreck, which was still lying in a scrap yard. That memory of grief, guilt, and love brought me back to Alt's photographs and cemented my bond with the victims of Hurricane Katrina, insuring that I would never forget them.

I invite you to have that experience in your own way as you let Jane Fulton Alt's emotive documents affect you.

Photographs and Stories

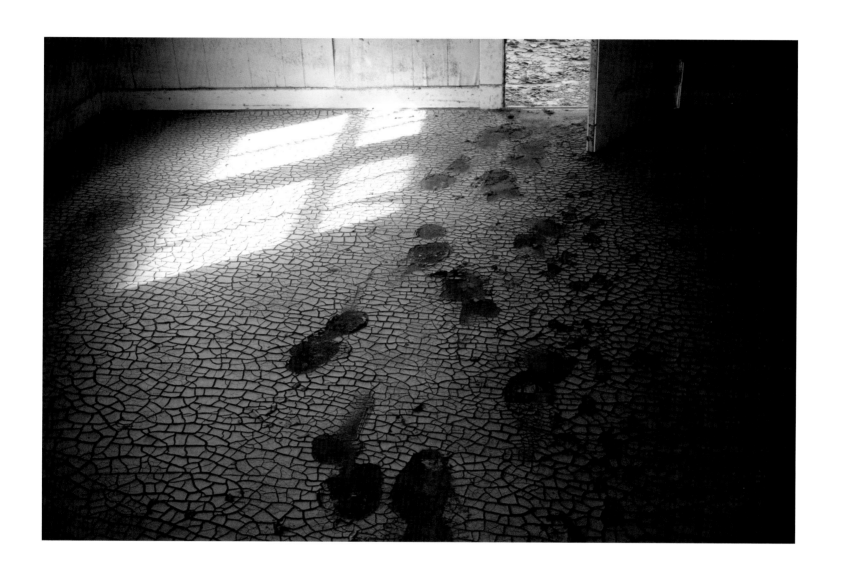

First steps back home, November 6, 2005.

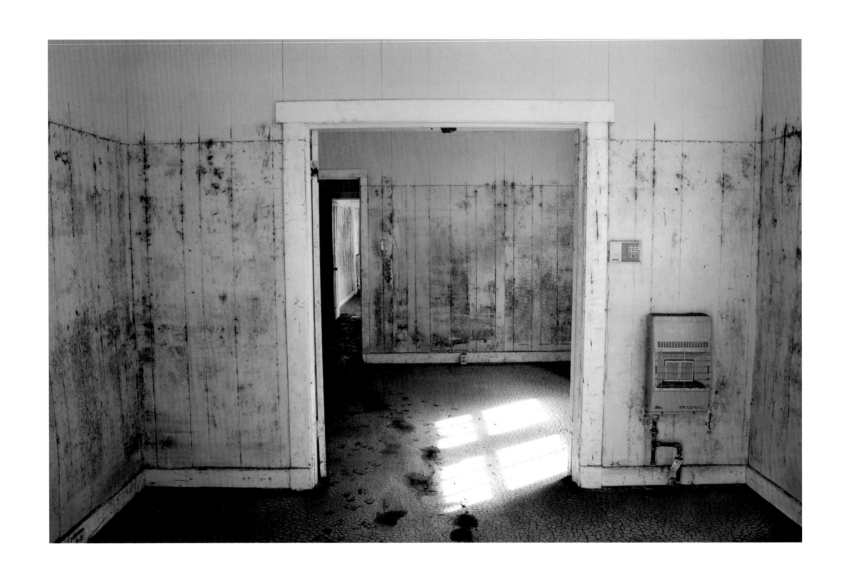

Water line, November 6, 2005.

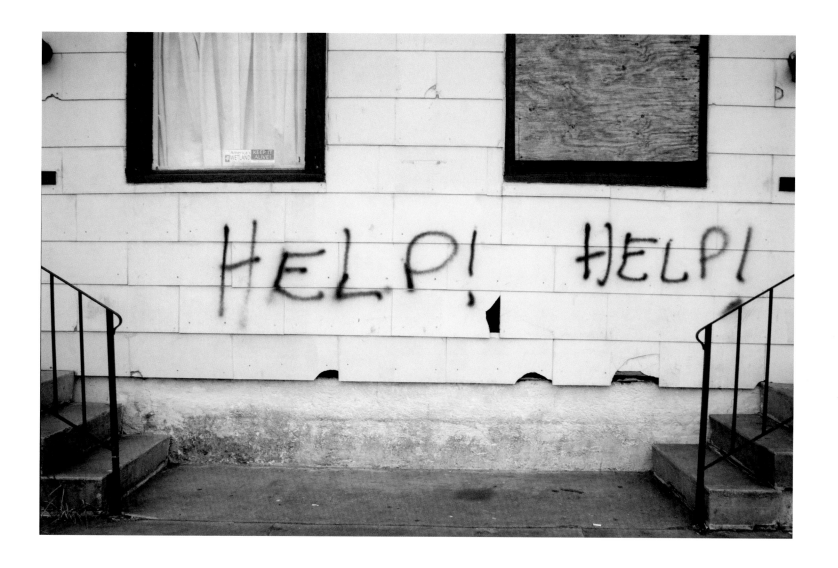

June 15, 2006.

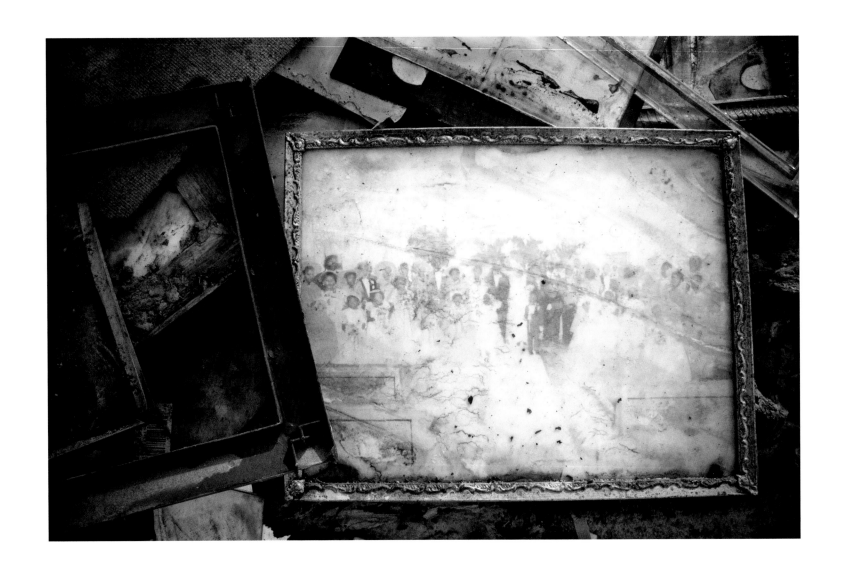

Wedding portrait, November 6, 2005.

Miss Victoria

Although suffering from a heart condition, Miss Victoria, a seventy-five year old widow, struggled to stay calm during her trip home. Two National Guard soldiers had brought her and her daughters in a van back to her house, but, because of its unsafe condition, Miss Victoria was not allowed to enter. She told Jonathan, one of the soldiers, that her wedding ring was in the house.

"Where is it, ma'am?" he asked.

"Go up the stairs, into the bedroom and to the dresser. It's in the third drawer, under the towels toward the back, in a box wrapped in a blue sock."

"I'll try, ma'am," he said.

Several minutes passed, and Jonathan came out of the house looking triumphant. He had the ring, he had some jewelry, and he had her late husband's driver's license. Miss Victoria was speechless with happiness. Her daughter, who had appeared jovial and strong, wept uncontrollably at the sight of her deceased father's driver's license.

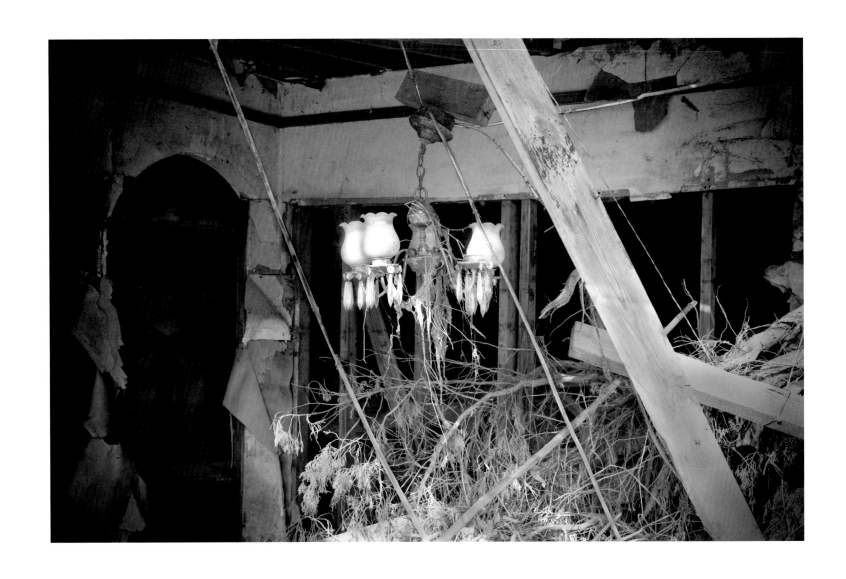

Dining room, November 14, 2005.

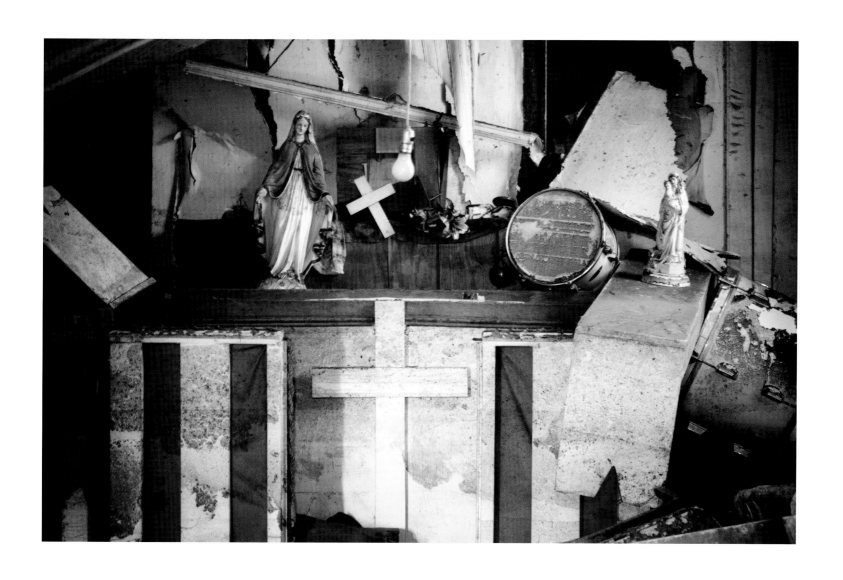

Church altar, November 13, 2005.

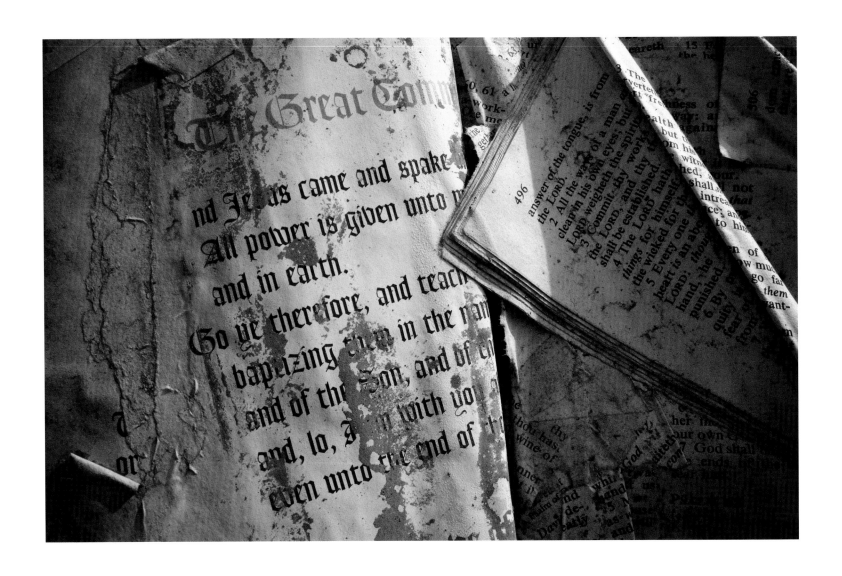

The Holy Bible, November 7, 2005.

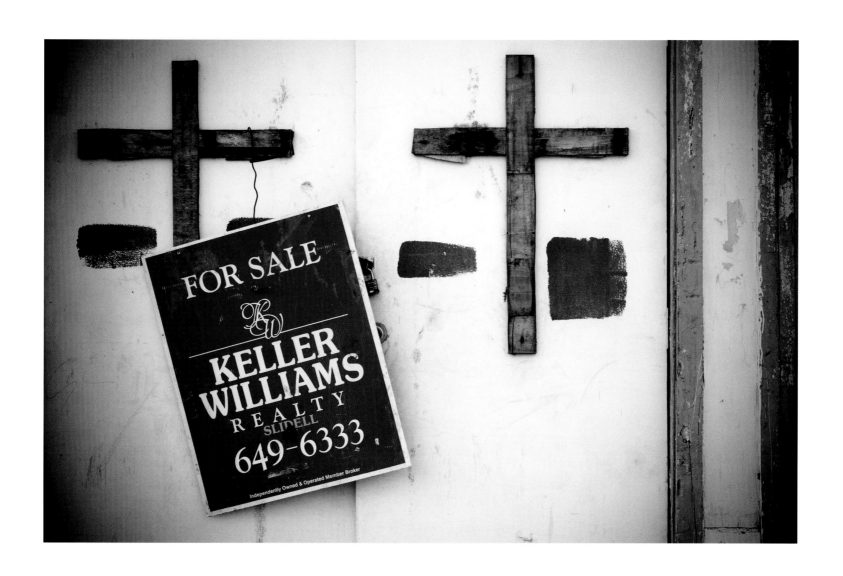

Church on St. Claude Avenue, November 6, 2005.

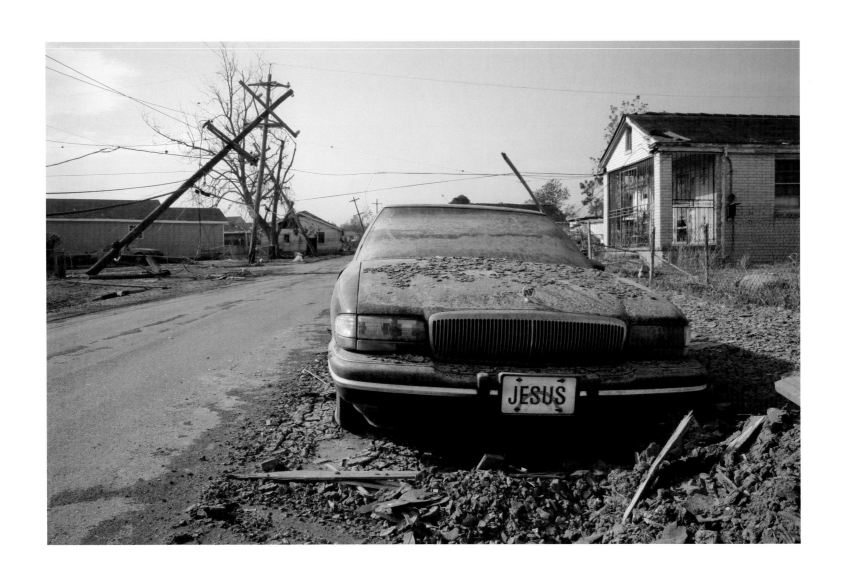

November 3, 2005.

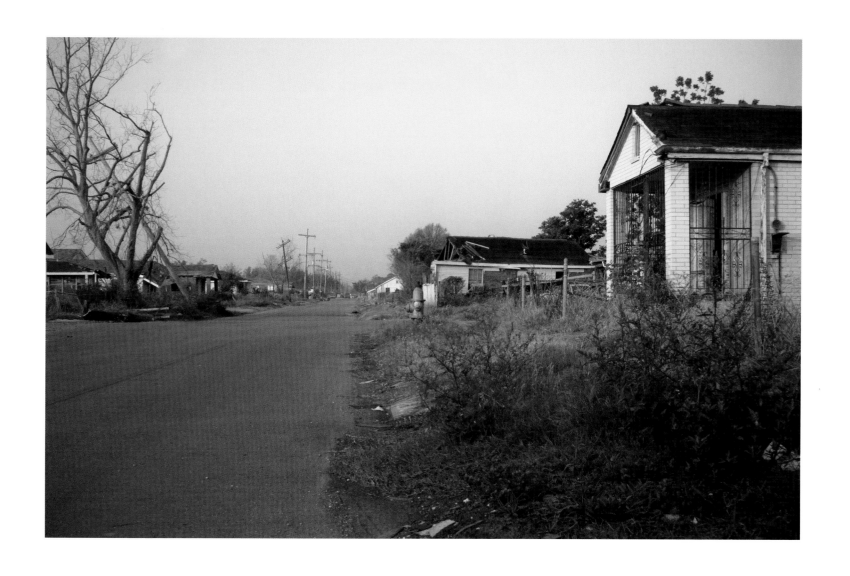

June 14, 2006.

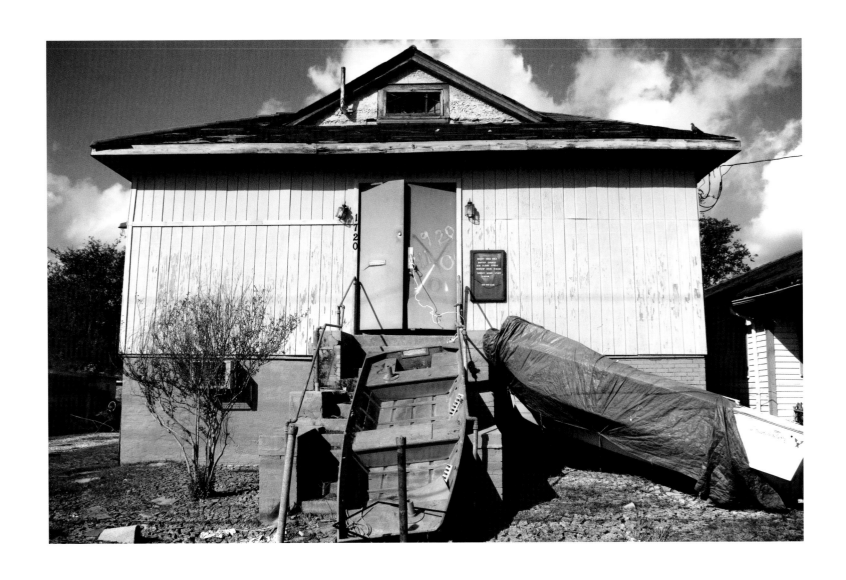

Mount Nebo Baptist Church, Flood Street, November 14, 2005.

The Reverend and His Wife

I had the privilege of accompanying a clergyman and his wife back to their home and church. Tall and handsome, with graying hair and a kind, gentle face, the reverend sat with me in the back of the van as we went to his home. He asked me where I was from, adding that he was sure this experience would change my life. Of his congregation of 150 people, he had spoken to, or knew the whereabouts of, each and every member.

We drove to his residence, two blocks from where the levee broke. He and his wife had remodeled their slate house the previous year. After the initial shock of seeing their home, they said nothing could have prepared them for the extent of the damage. The reverend and his wife spoke fondly of their neighbors, reminiscing about the good times.

They told me about their neighborhood: where Miss Bessie lived, where Miss Rose had her annual holiday party, about another church that had just completed the final renovations of a ten-year building plan, the $20,000 fence a neighbor installed on his mother's property, and the orange tree that died in the hurricane after its most productive year ever. They also described, in loving detail, each plant that had once thrived in their garden.

As they inspected their home, I heard a howl of laughter. His wife turned to me and said, "I had been bugging him for weeks to move that plant container . . . look, it is still there, hanging in the same place . . . he never did move it."

As we returned to the "Look and Leave" site, the reverend asked if he could walk to his church. The colonel in charge of the operation said "no," because it was too dangerous. The reverend graciously replied that he had served in the Army and understood the need to follow orders.

We climbed into another van and drove to the church accompanied by a soldier. The reverend walked around the church property inspecting the damage. He asked to go inside. We made our way slowly up the stairs and carefully opened the door. Just past the vestibule a very tall ladder extended into the attic of the church. The reverend expressed relief that he had left the ladder there. Someone had been able to use it.

He pointed out the pulpit, now lying on its side, from which he had preached many sermons. We remained in the doorway because the space was so toxic and unstable. The soldier went in and recovered a needlepoint of the Lord's Prayer that the reverend's wife had made, some small statues, and a photograph of the entire congregation. The birds that had claimed the church as their own took flight when the photo was removed from the wall. The reverend said that all creatures need shelter. He was glad that his church still provided sanctuary for so many.

As he transferred the recovered items from the van to his car, he said, "God takes away, but He has something better in mind for us. This has always been true. I just need to wait and see what He has in mind for us this time." I extended my hand out to him to say goodbye. "I'll take a hug," he said, and then added, "Pray for us."

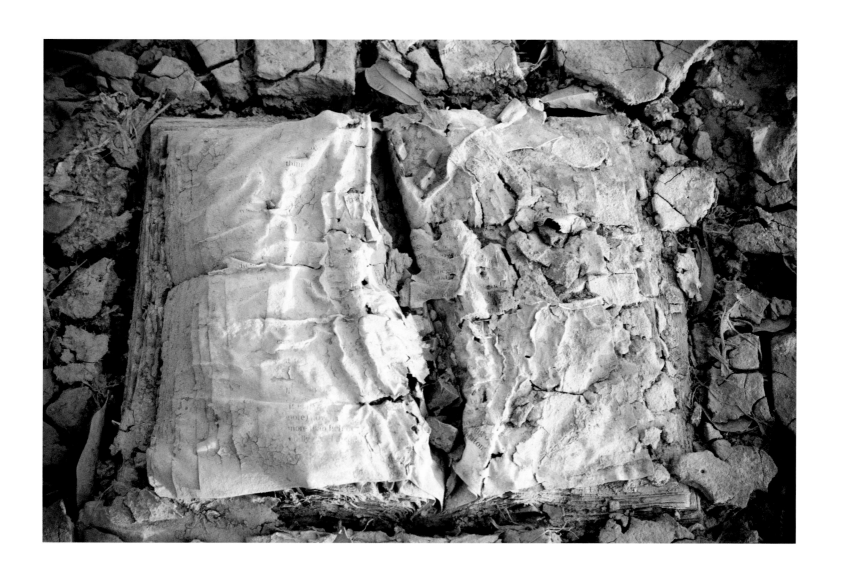

North Claiborne Avenue, November 7, 2005.

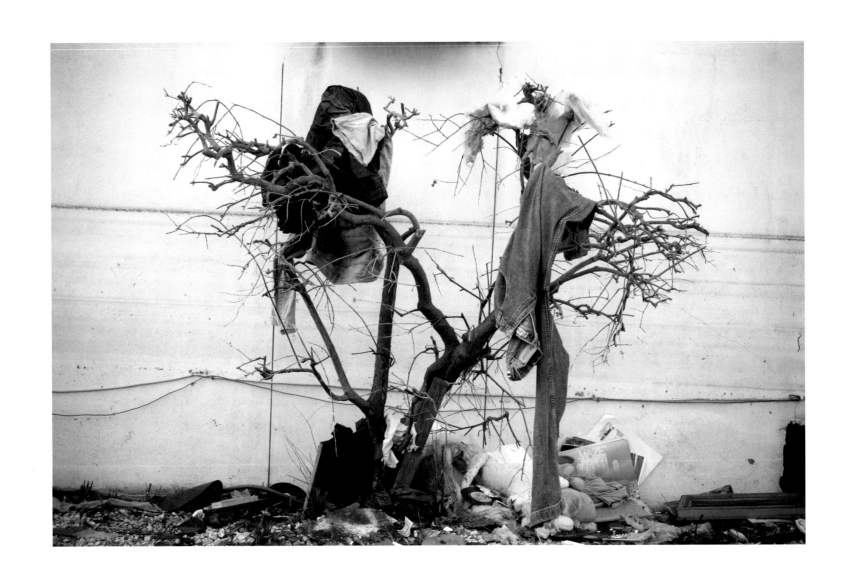

Schoolyard, November 10, 2005.

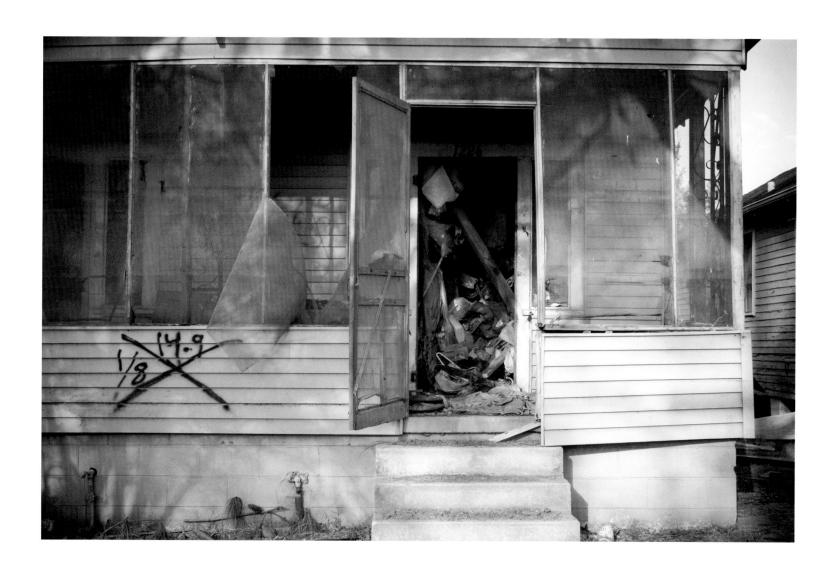

November 10, 2005.

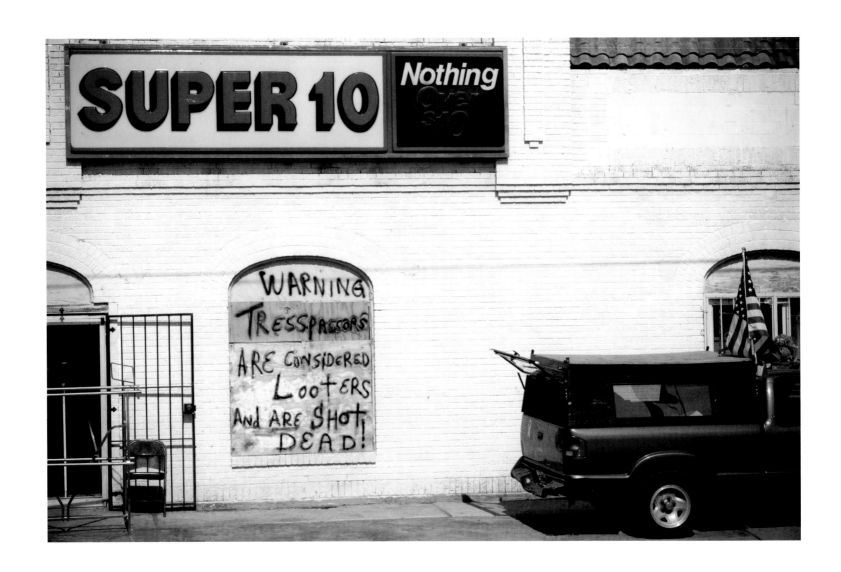

St. Claude Avenue, November 6, 2005.

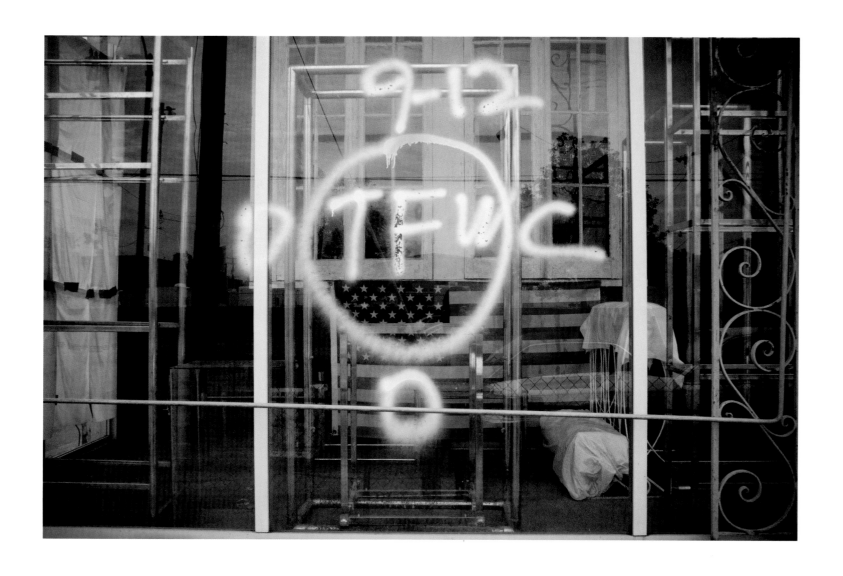

St. Claude Avenue, June 16, 2006.

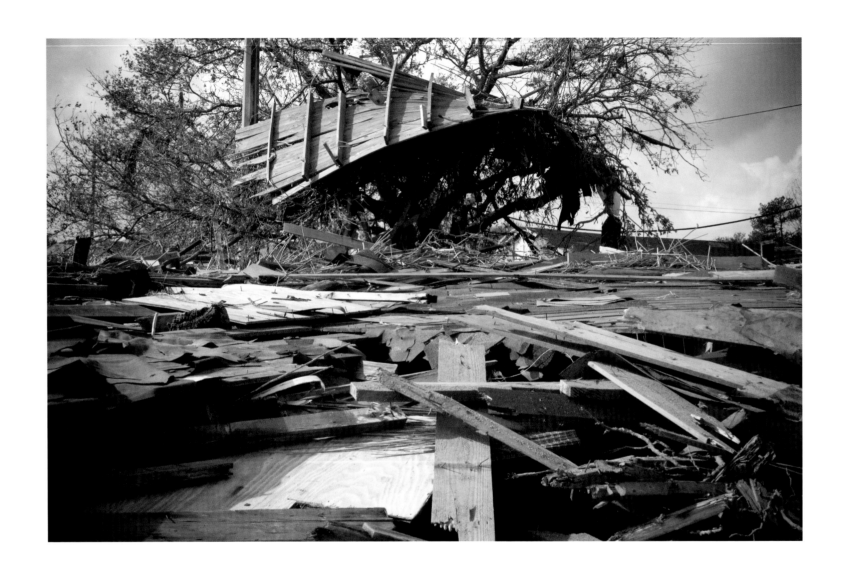

The tree that saved a life during Katrina, November 6, 2005.

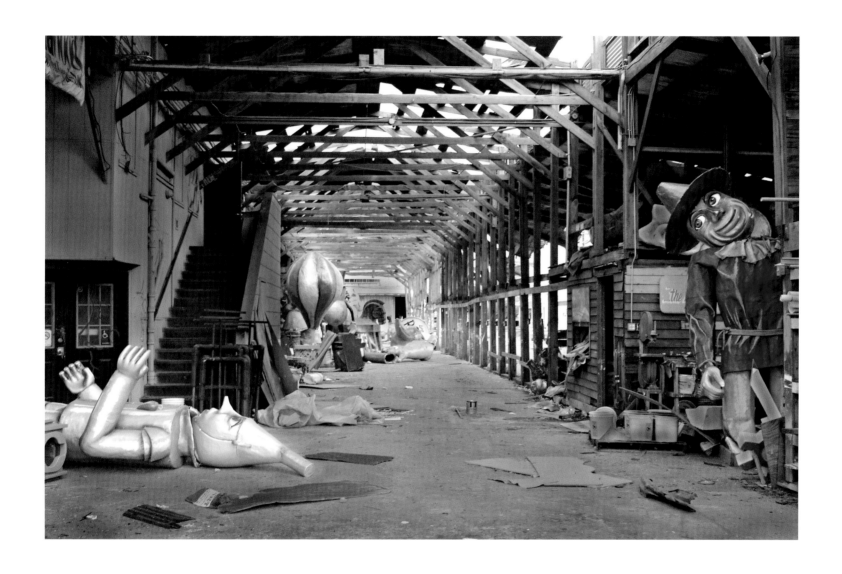

Mardi Gras warehouse, June 16, 2006.

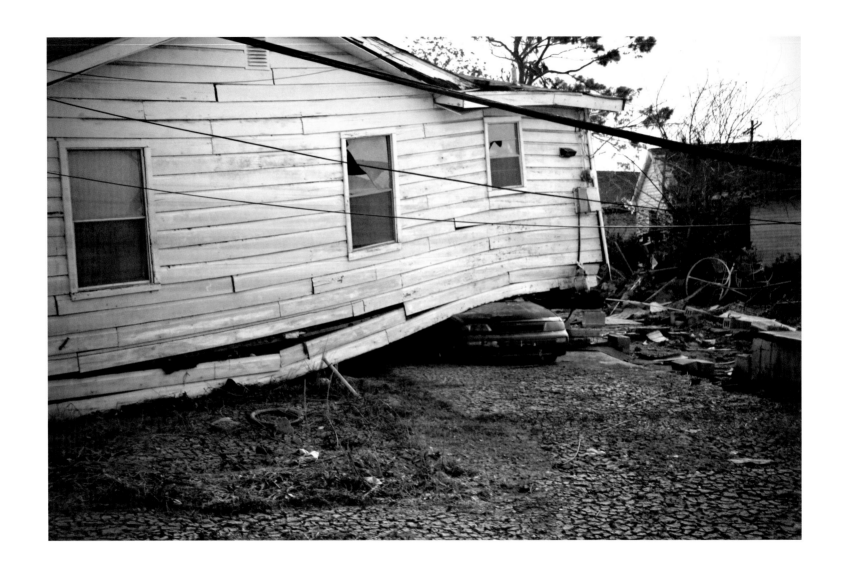

November 3, 2005.

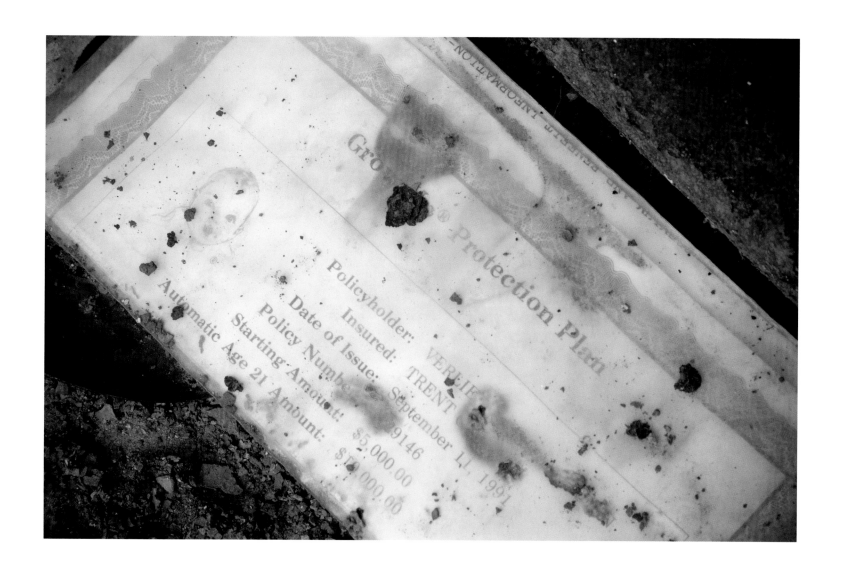

June 16, 2006.

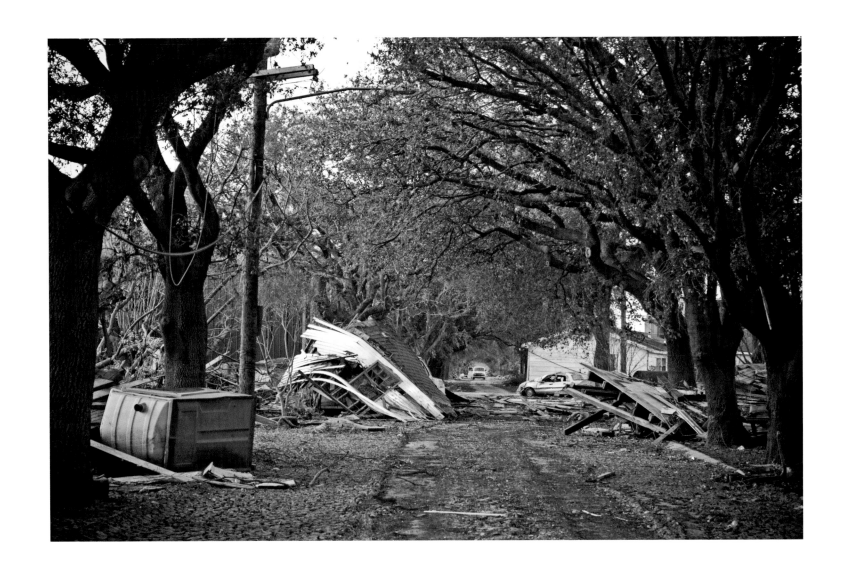

Andry Street and Florida Avenue, November 14, 2005.

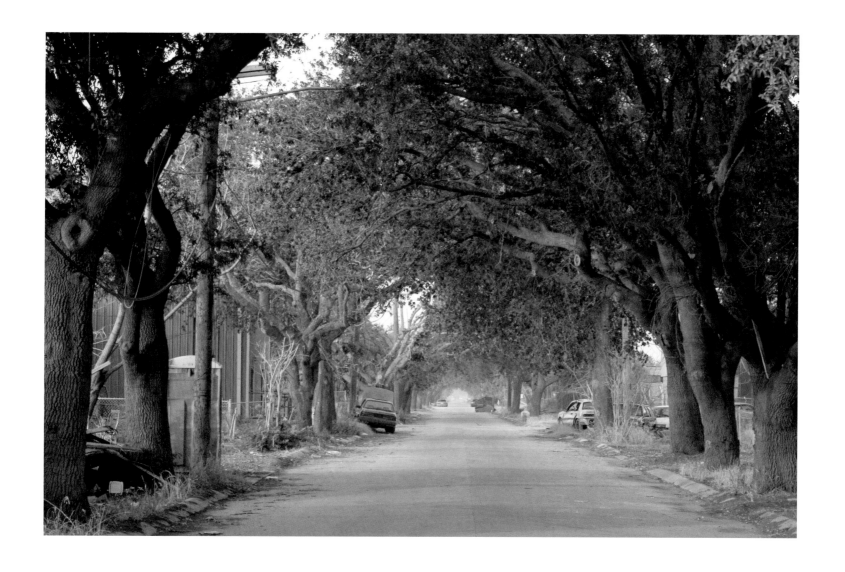

June 14, 2006.

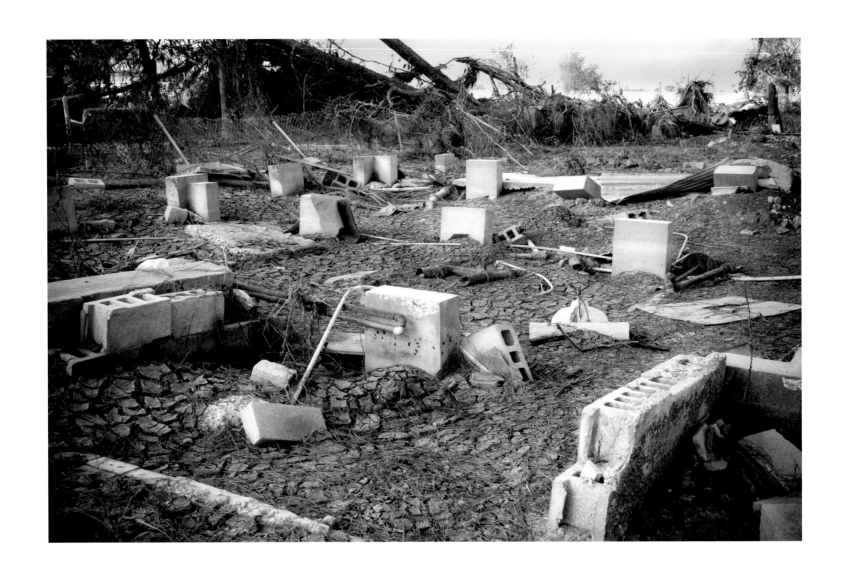

November 14, 2005.

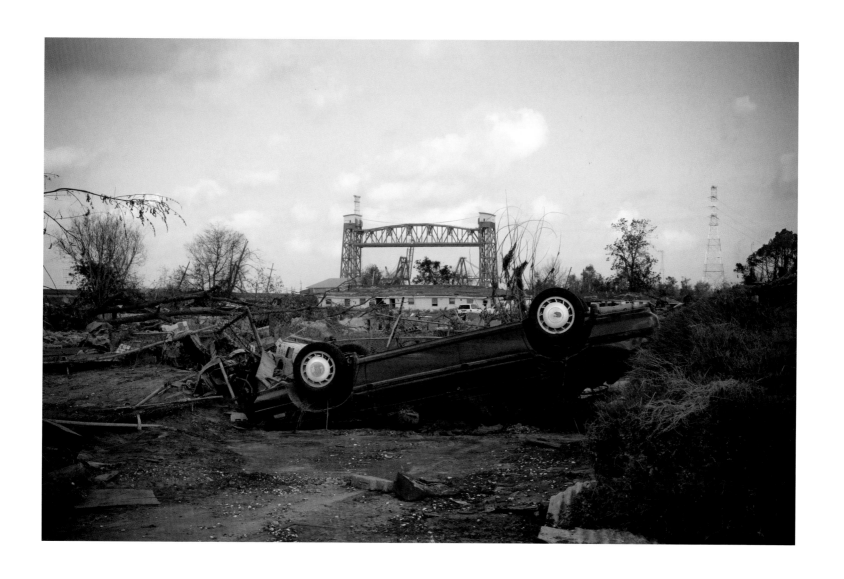

The Florida Avenue bridge along the Industrial Canal, November 14, 2005.

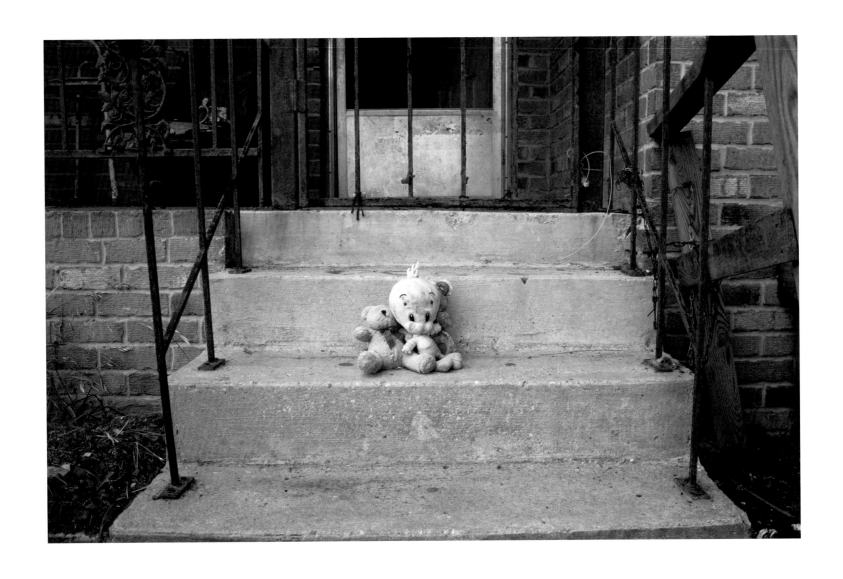

June 16, 2006.

Samantha

Six-year old Samantha was on the bus with her parents, brother, and sister. A fellow team member, Mary, spent a long time talking with Samantha to distract her from the destruction visible from the bus window. Samantha sat next to Mary and read to her from a book we had distributed to help children deal with the crisis. The book had lots of poems, which Samantha read with pride. One of the poems used the word "dare." "What does 'dare' mean?" Samantha asked.

"Well, if you dare to do something, you probably have courage. Do you know what 'courage' means?"

"Yes," she said, "If you have courage, it means that your house won't fall down."

Later on the bus, Samantha noticed that the book had one page devoted to the song "This Little Light of Mine." Mary asked her if she knew the song. Samantha told her that she not only knew the song, but that she could sing it. And so, wearing her face mask to protect her from the contaminated air, she began: "This little light of mine, I'm gonna let it shine" Ever so softly, people on the bus around her picked up the song, made famous by Fannie Lou Hamer during the Civil Rights Movement, and soon everyone on the bus was singing in unison.

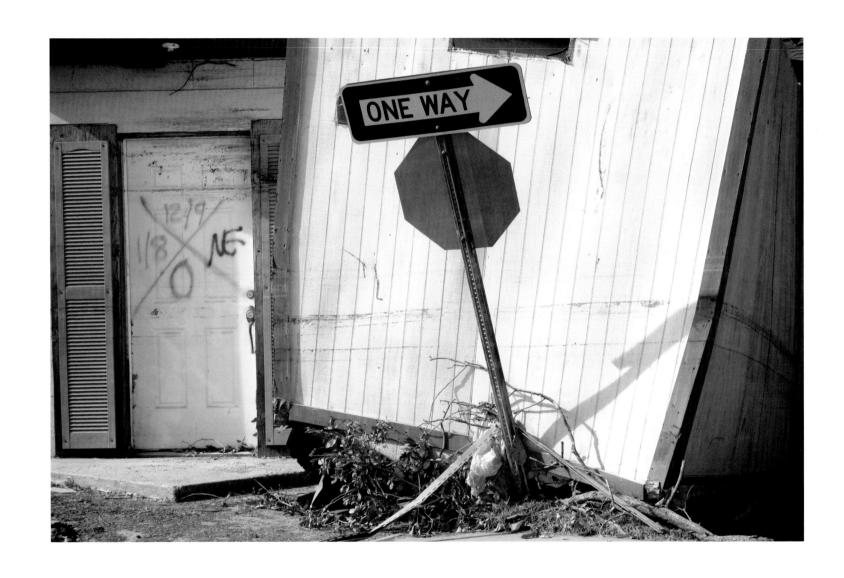

November 6, 2005.

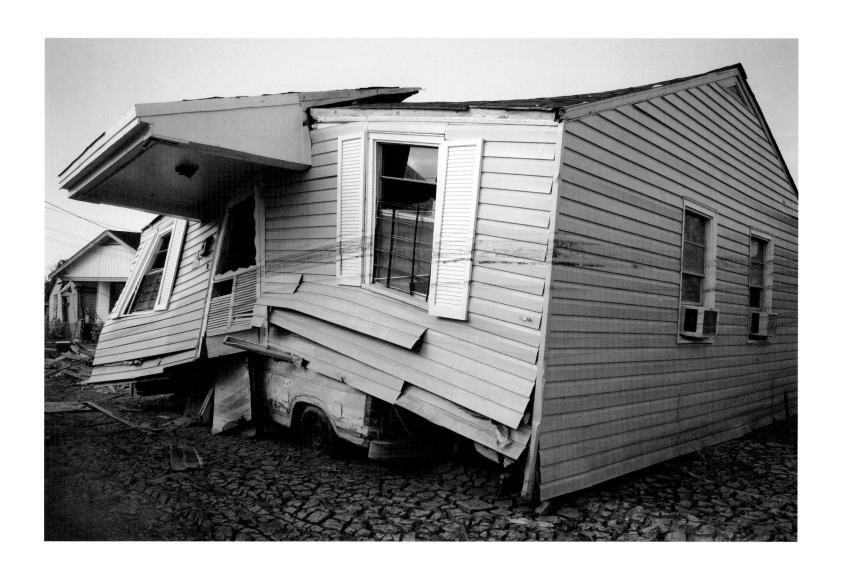

November 6, 2005.

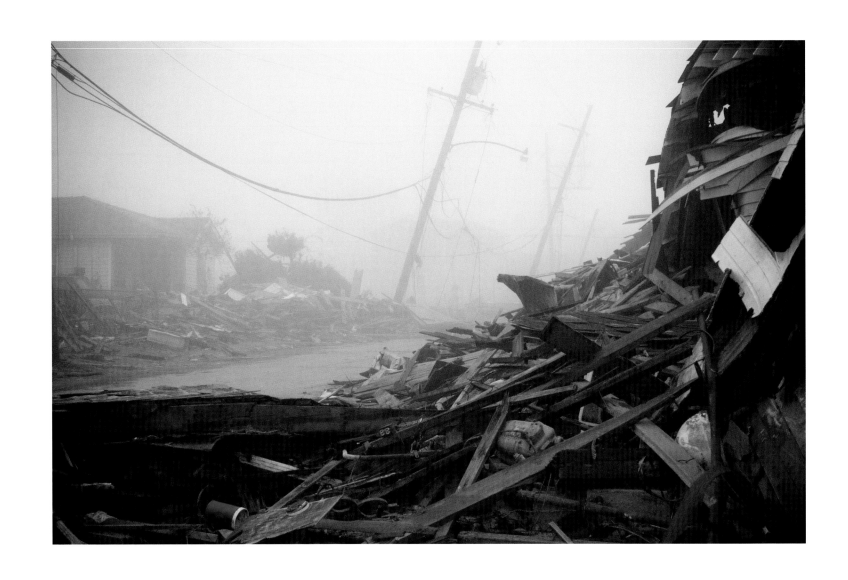

November 8, 2005.

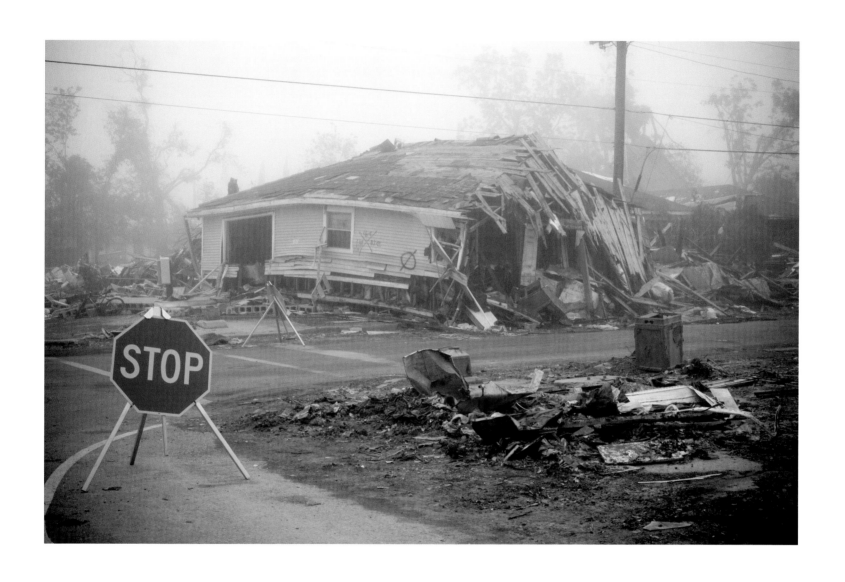

North Claiborne Avenue and Forstall Street, November 8, 2005.

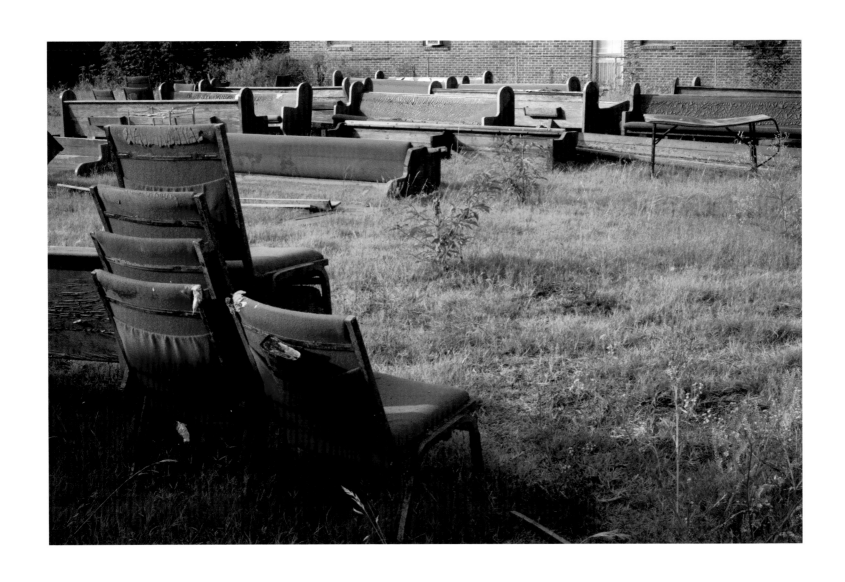

Battleground Baptist Church, June 14, 2006.

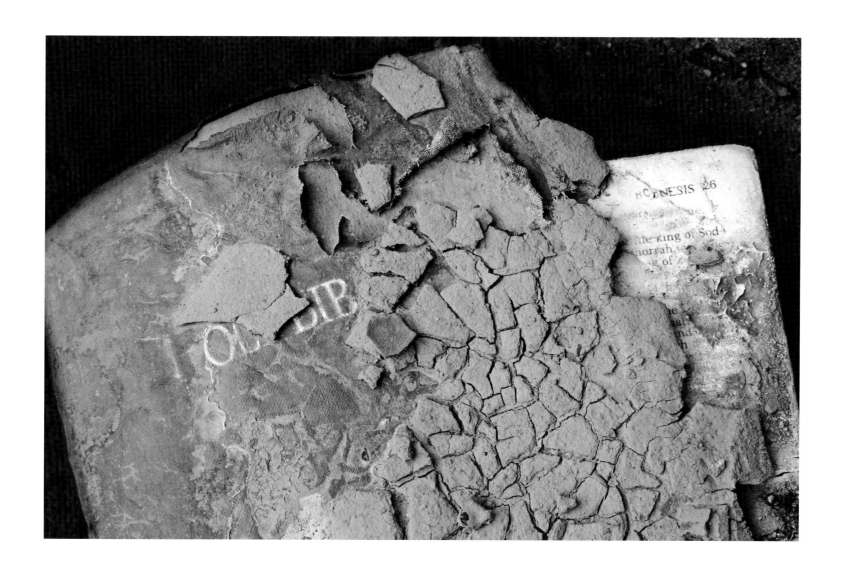

Genesis, June 16, 2006.

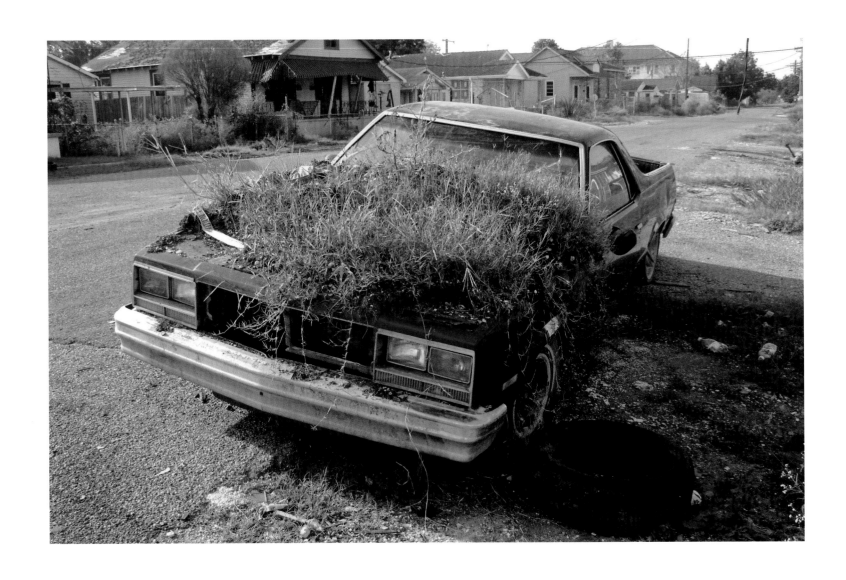

September 23, 2006.

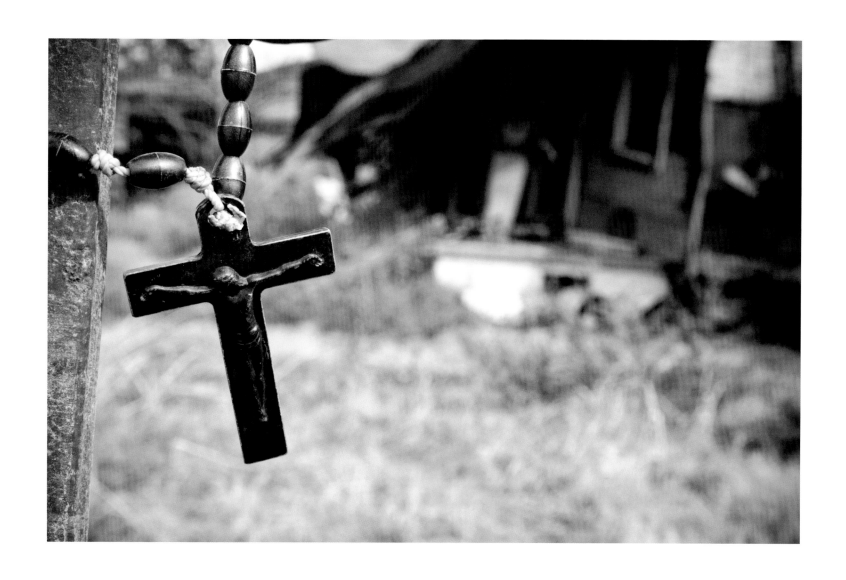

June 15, 2006.

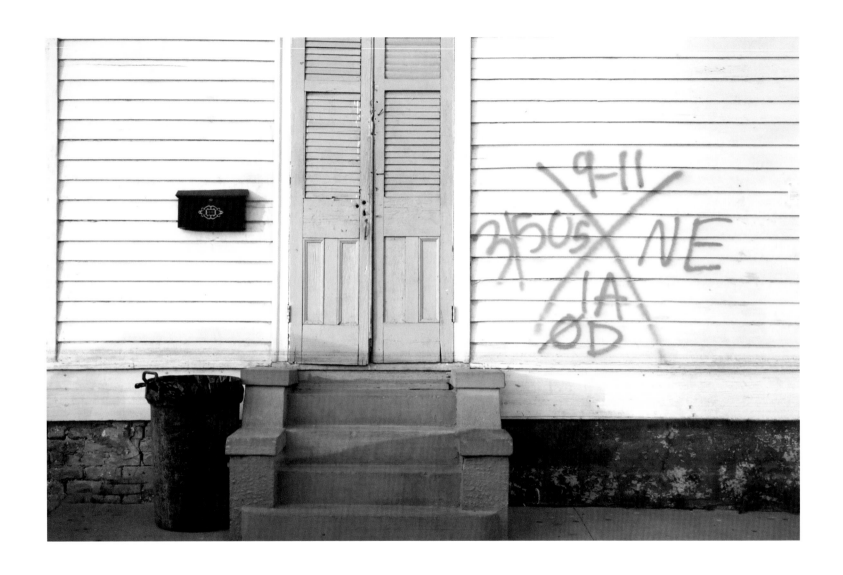

November 10, 2005.

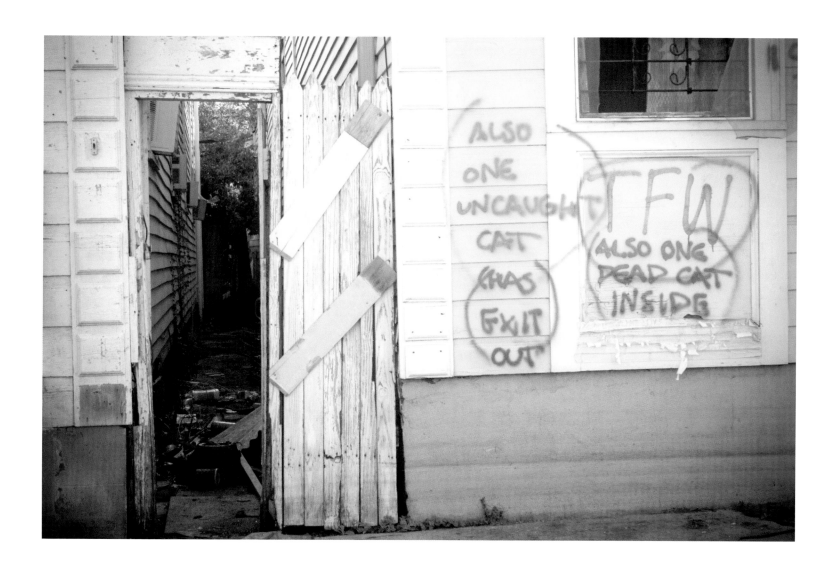

November 13, 2005.

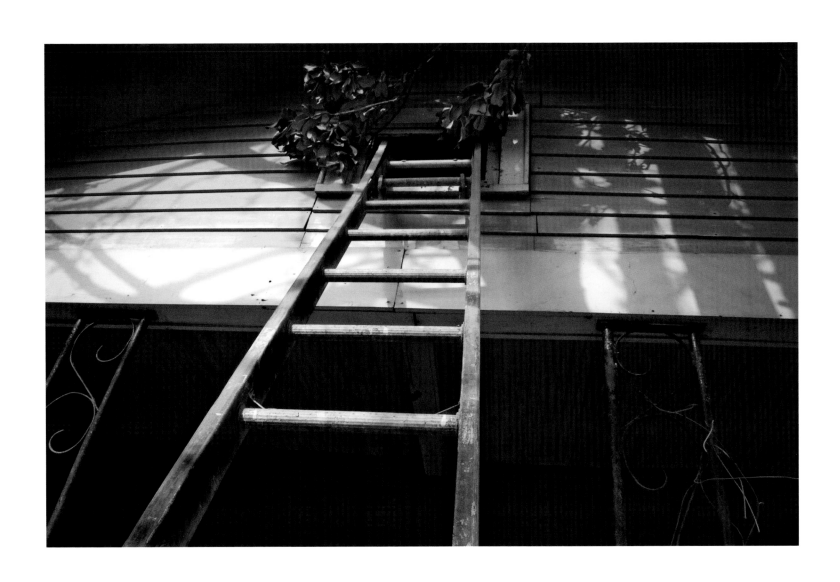

November 11, 2005.

The Nurse

I met with a nurse who had sent her children on ahead so she could help her mother evacuate. As the time passed and the water rose, she became trapped in her attic. She said she would never forget the things she saw and heard. The water was filled with alligators, fish, and snakes. She heard the last gasps for air from animals and people going under. She heard people yelling for help in their attics, knocking on their ceilings, only to be silenced by the rising water.

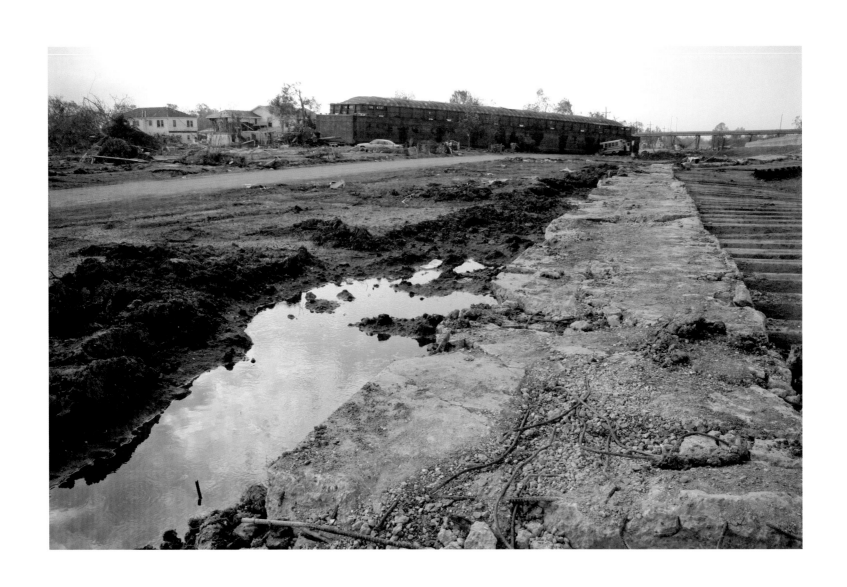

Along the Industrial Canal, November 3, 2005.

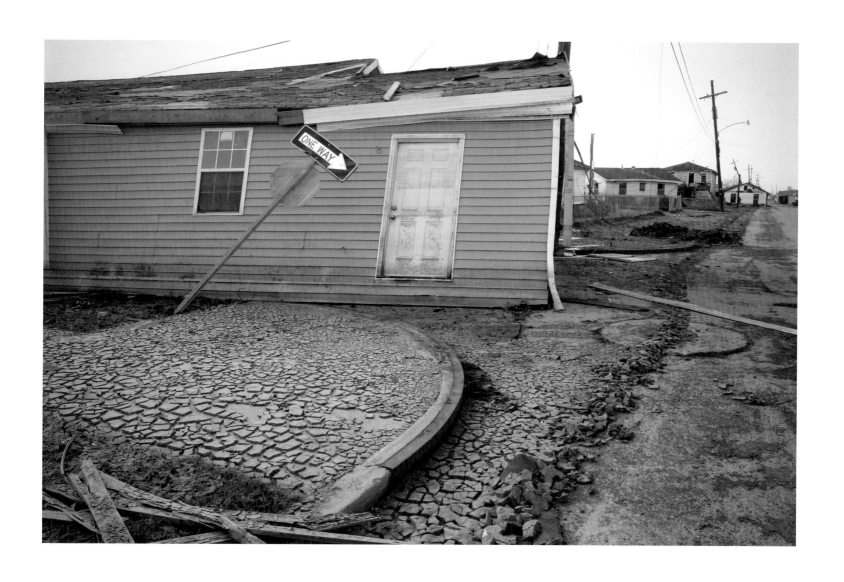

November 3, 2005.

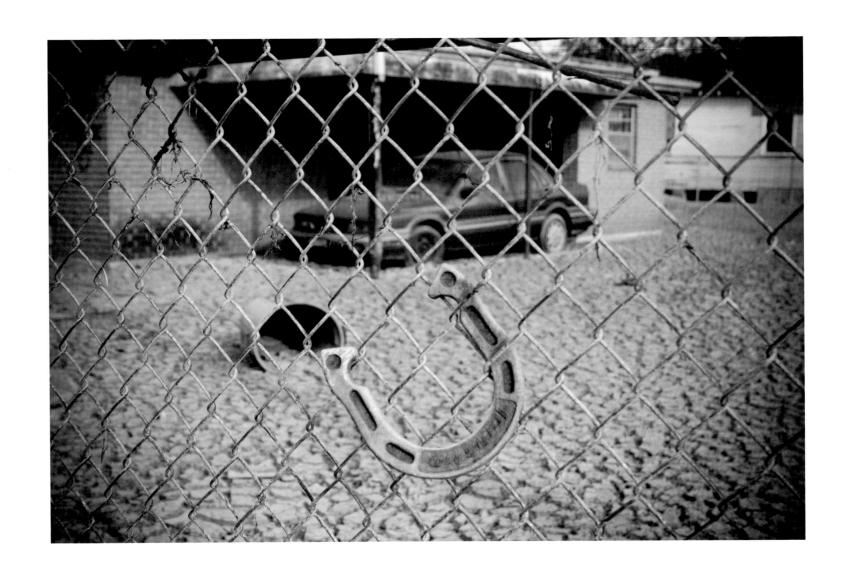

November 6, 2005.

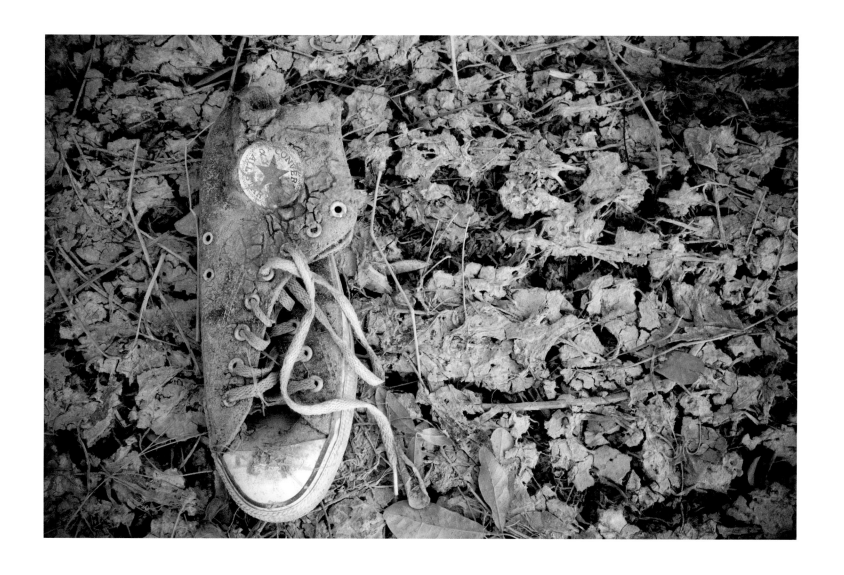

November 7, 2005.

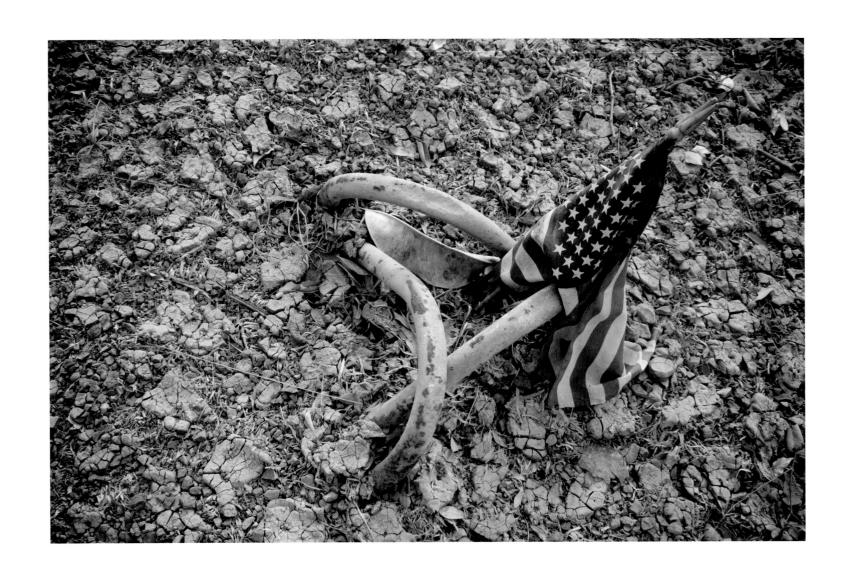

Front yard, November 6, 2005.

The Nameless Woman

There was a nameless woman who came to the site, caked with mud and dirt, shoeless, wearing only underpants and a T-shirt, shouting obscenities, and enraged at whomever came near her. She was out of control and clearly psychotic. One of our team members, Megan, followed the woman back to her home to help her into a police van. The woman resisted, repeatedly yelling at Megan to leave her alone. After numerous attempts to shake free, the woman said: "You aren't going to stop following me, are you?" to which Megan replied: "No, I'm not. I will not stop following you until I know you're safe."

Eventually, the police took her to one of the few functioning hospitals. Though we never learned her name, she did say that she watched her mother drown in the house just down the street from her. I believe that. I also believe that her "madness" was simply an overt expression of what most people on those buses were feeling. The difference was this: they contained it. She wailed, she shouted, she protested, she kicked, she screamed, she said a resounding "no" to reality. Who of the other residents would not have wanted to do the same?

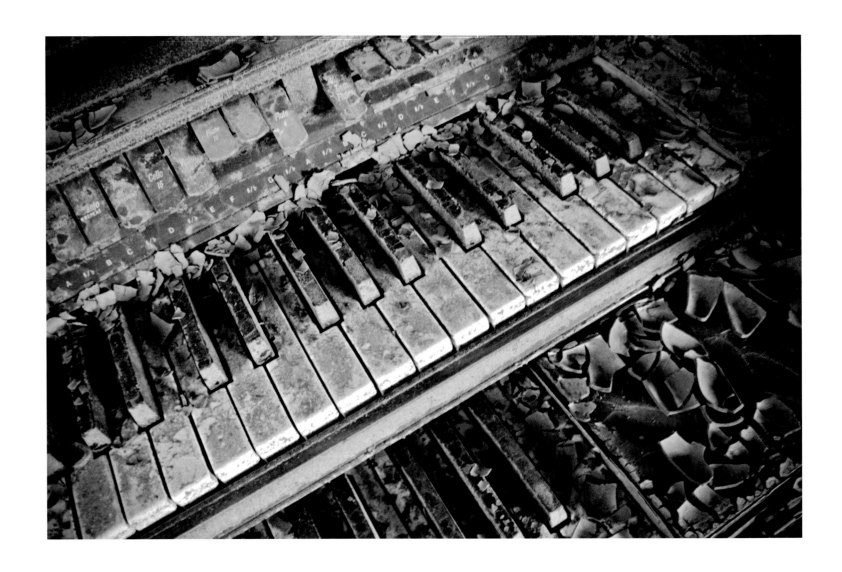

Church of the Living God, June 16, 2006.

Church pew, June 15, 2006.

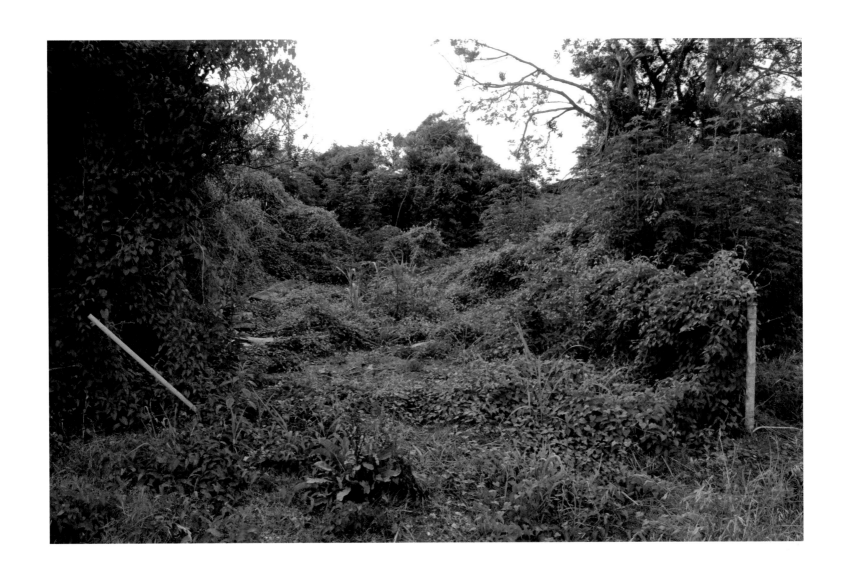

June 16, 2006.

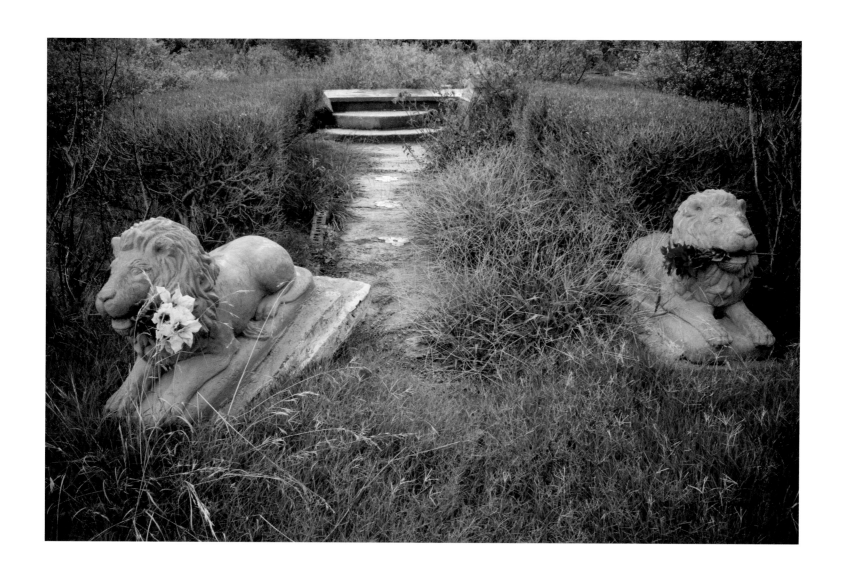

June 15, 2006.

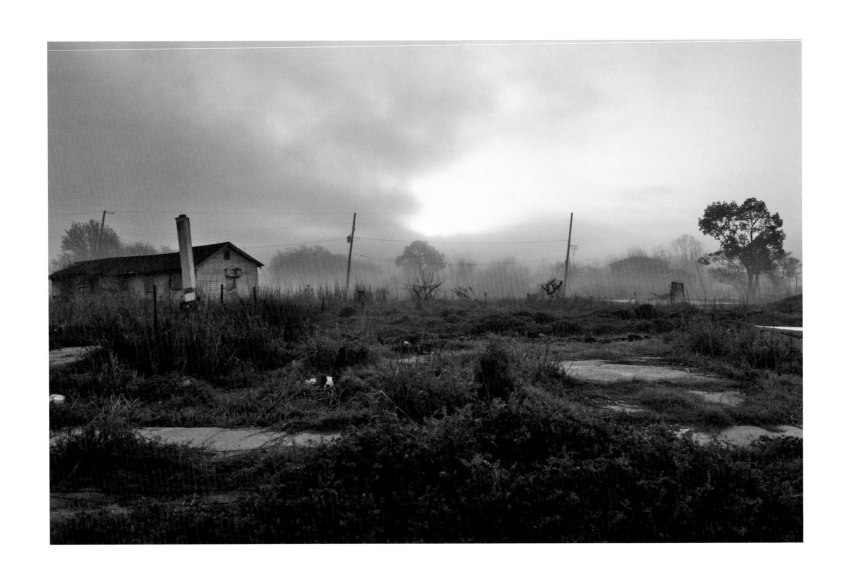

February 26, 2007.

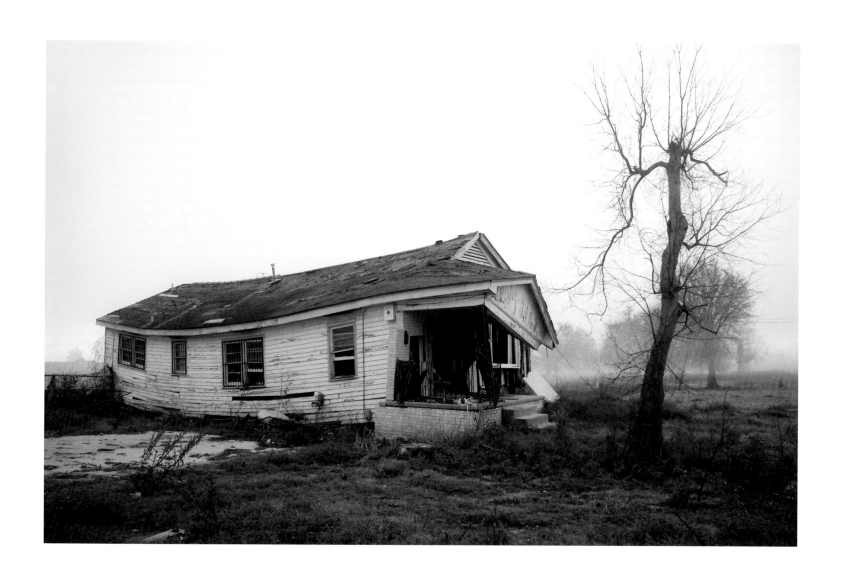

February 26, 2007.

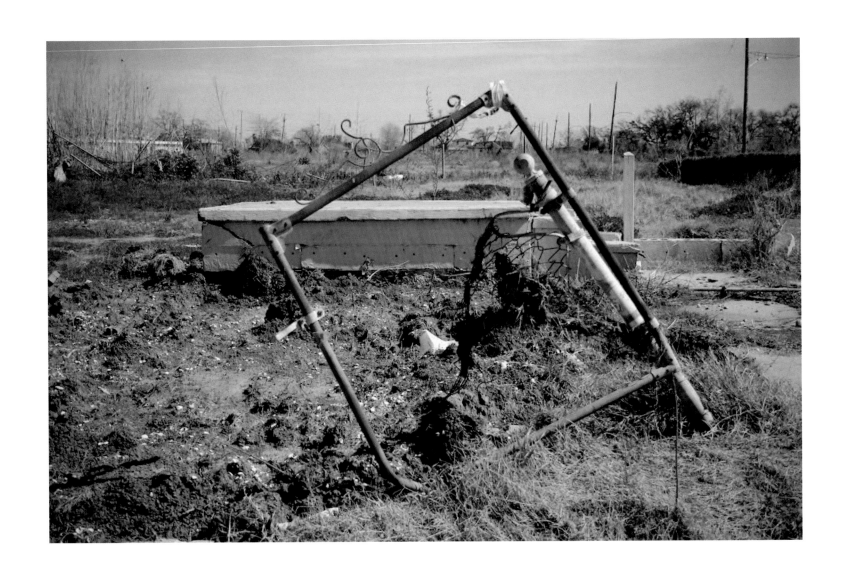

February 25, 2007.

Inch by Inch

I returned to the Lower Ninth Ward for the third time in February 2007, a year and a half after Katrina. Few homes remained standing; most had been razed or were awaiting demolition. To my surprise, I spotted a man raking away contaminated topsoil in his yard. There was a fruit tree standing that had been pruned back to a ghost of its former self.

I stopped my car and got out, hoping to learn more about this man's journey back home. I was warmly greeted. His name was Frank. He said that many of his former neighbors did not approve of his return to the neighborhood, but his unrelenting heartache led him back. He had been born and raised in his home, with his entire extended family living within a two-block radius. "I am going to die sometime, and, when I do, I'd rather do it at home. If it takes me years, I am going to reclaim my home from the damage Katrina has inflicted, inch by inch." Frank wakes up at 5 a.m. every day to report to his factory job. After a full day of work he returns home and continues the reconstruction of his house for another two hours. He proudly took me on a tour of the renovated rooms. He and his wife lived a FEMA in a trailer on the property, but he hoped to move back into the house sometime during the coming year.

As I was preparing to leave, he invited me to dinner. Though I was unable to stay, he insisted that, upon my return, I promise to join him and his family for the best barbeque in all of New Orleans.

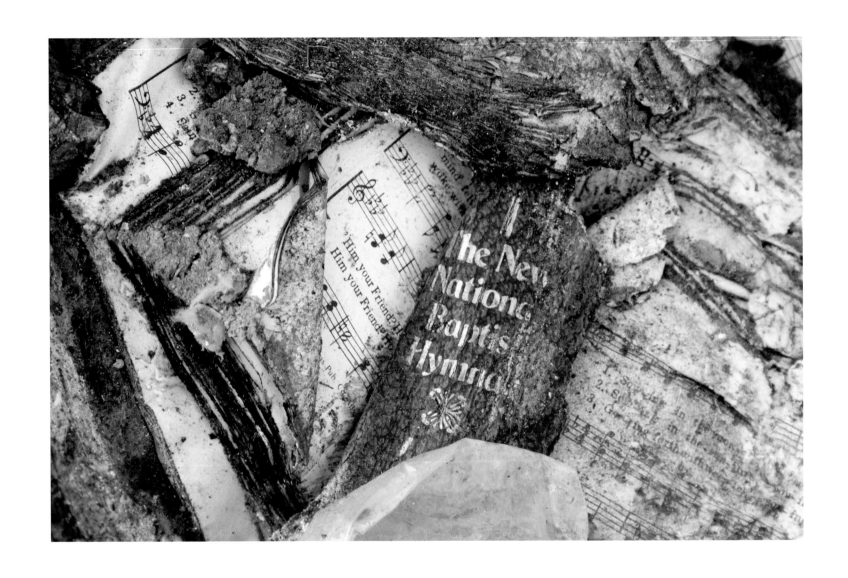

June 14, 2006.

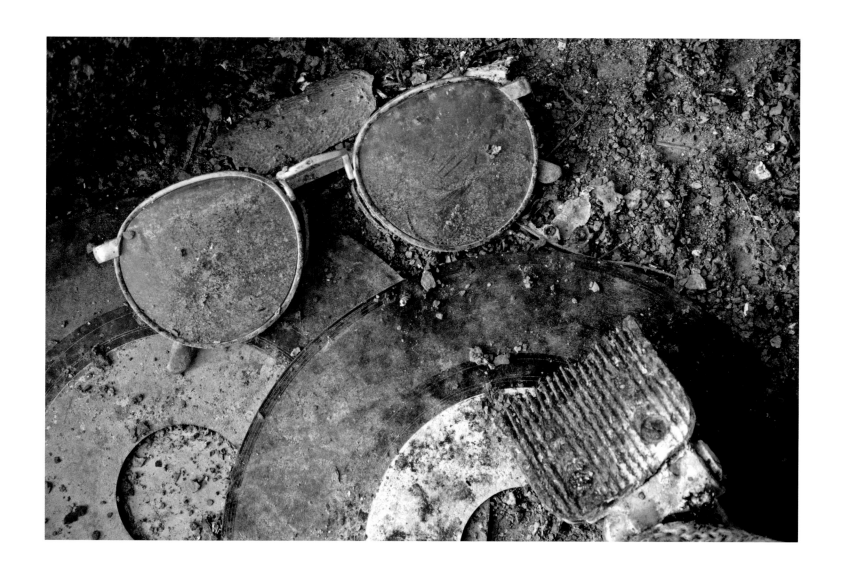

June 16, 2006.

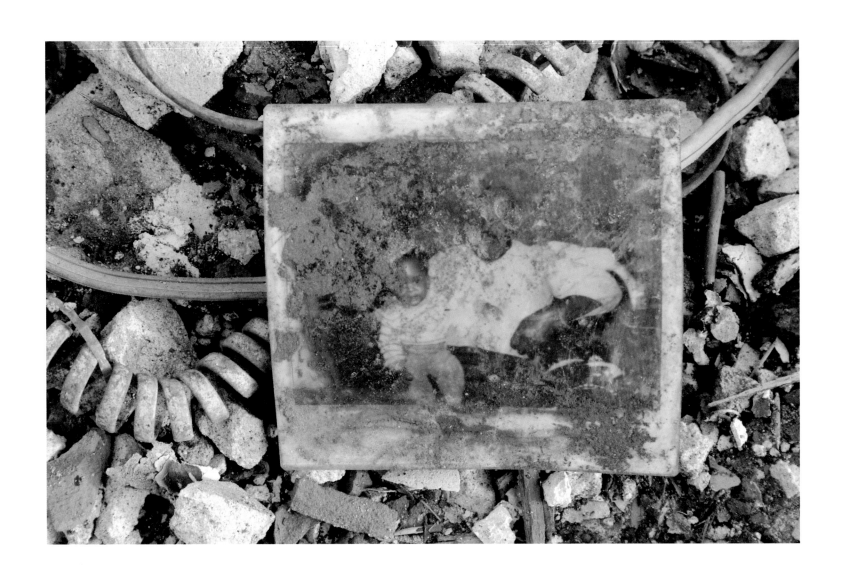

June 16, 2006.

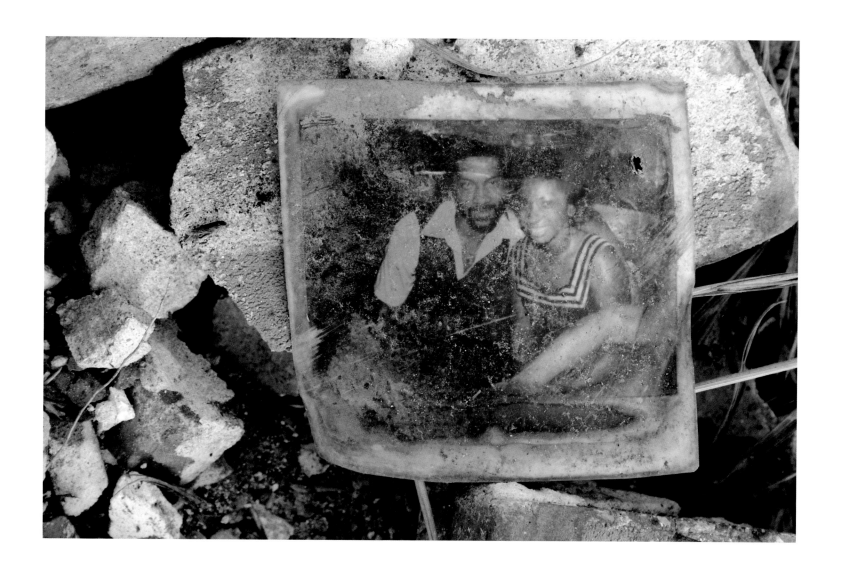

June 16, 2006.

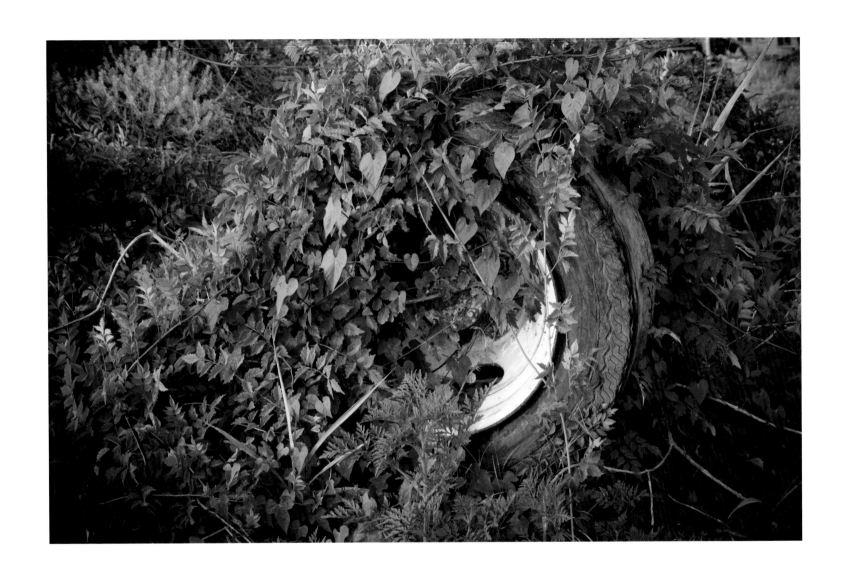

June 14, 2006.

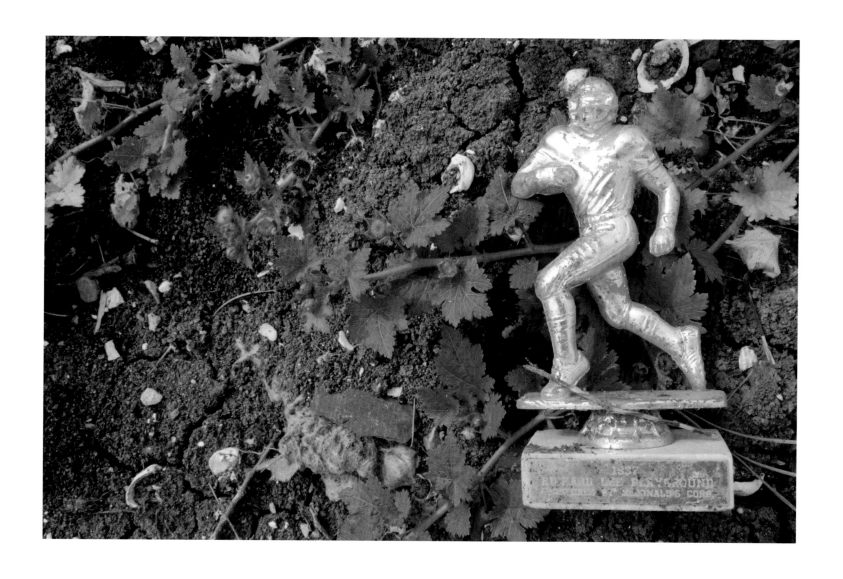

June 15, 2006.

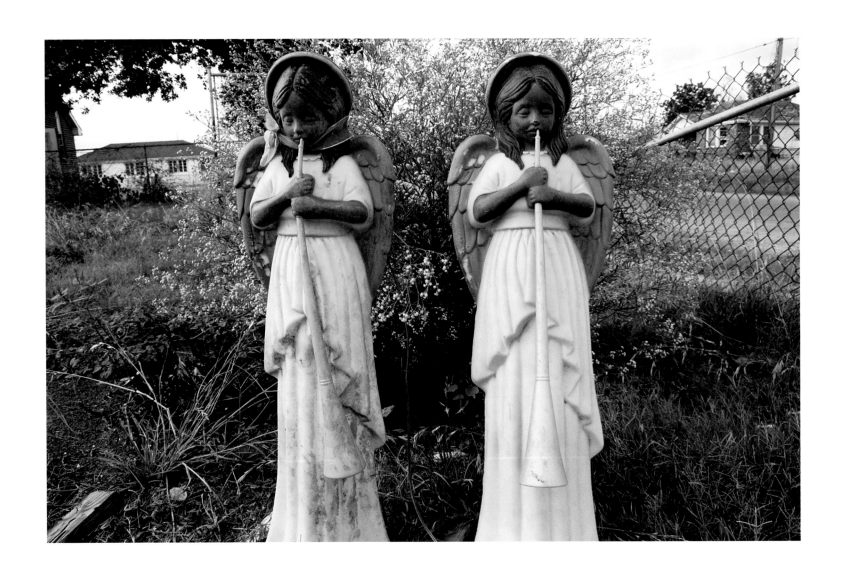

June 16, 2006.

On Jasmine and Recovery

After inhaling toxic metallic air for days in the ravaged Lower Ninth Ward, I went to a nearby neighborhood for dinner. While walking to the restaurant I passed a jasmine plant. As the rapturous fragrance enveloped me, I was jolted into an awareness that, even after all the destruction and unsettling experience of disparity, the contaminated soil of the Lower Ninth Ward might yield life once again.

On my subsequent returns to New Orleans, I have witnessed this slow return of life. A new health clinic has opened in the Lower Ninth Ward, the first anchor in an otherwise desolate landscape. Vibrant, innovative charter schools have sprouted, and dedicated teachers are creating a culture in which the students can succeed . . . and it is working. Construction of sustainable, affordable housing is now underway, thanks to the support and commitment of so many people. The Lower Ninth Ward of New Orleans is gradually redefining itself after being forever altered by man and nature.

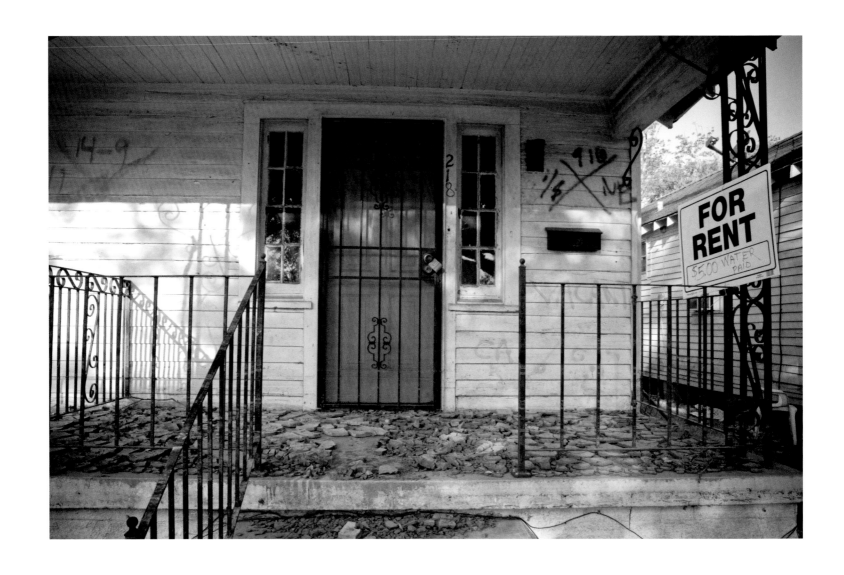

November 10, 2005.

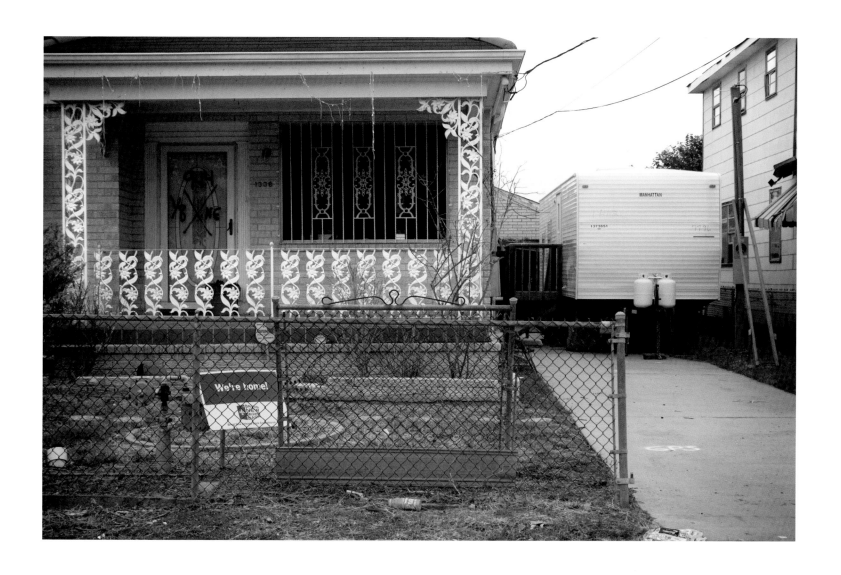

June 16, 2006.

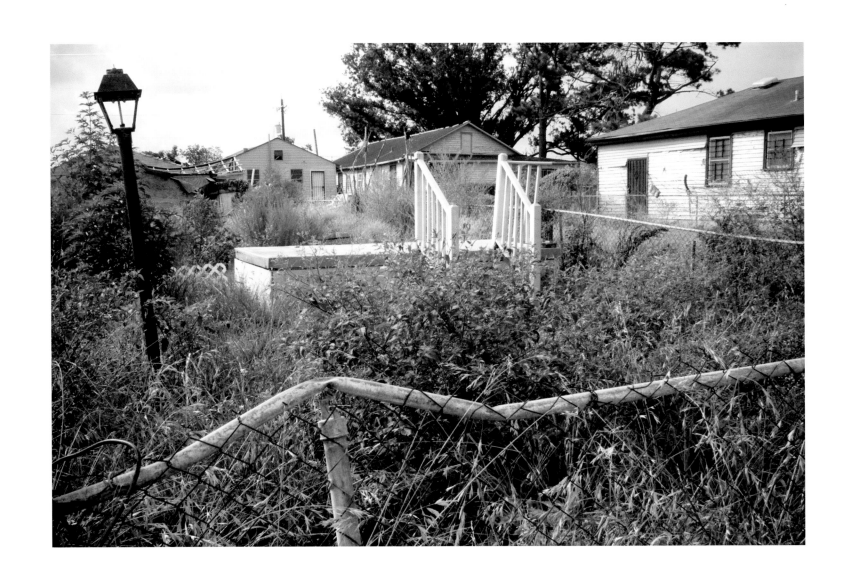

June 15, 2006.

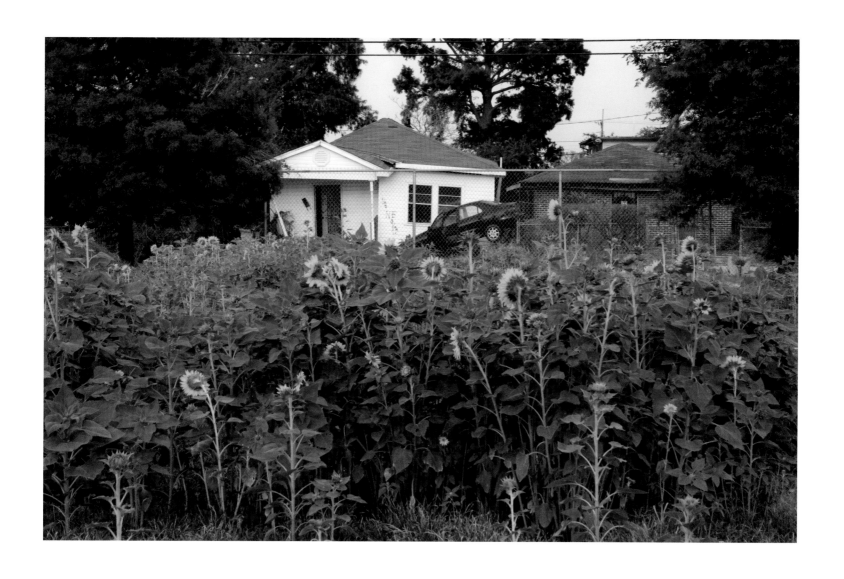

June 16, 2006.

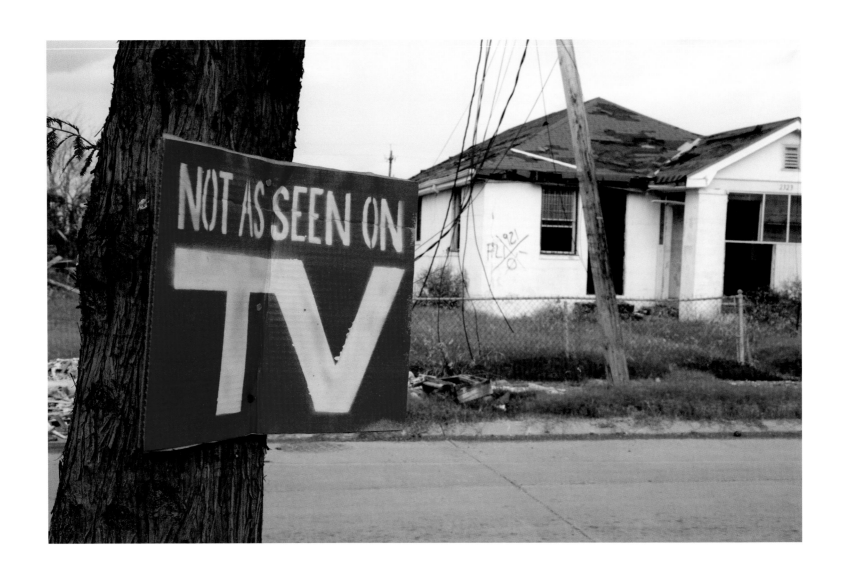

North Tonti Street and Caffin Avenue, June 16, 2006.

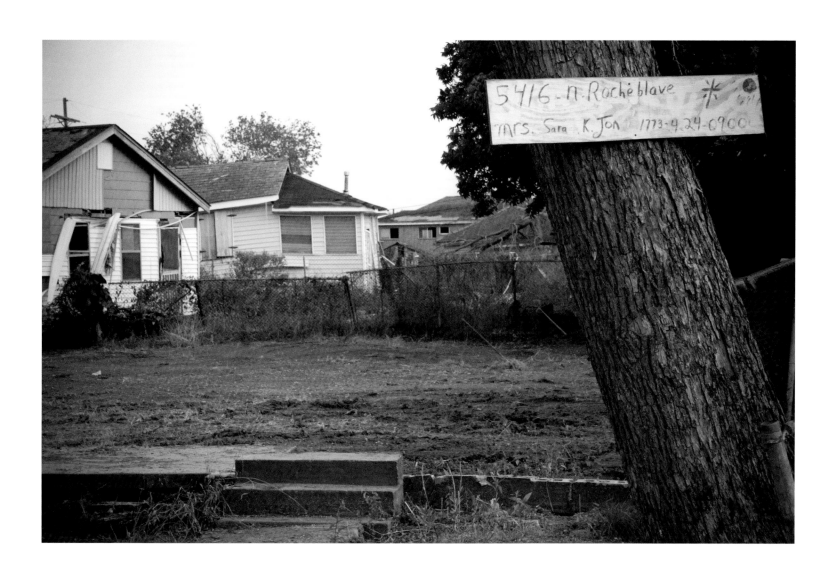

June 16, 2006.

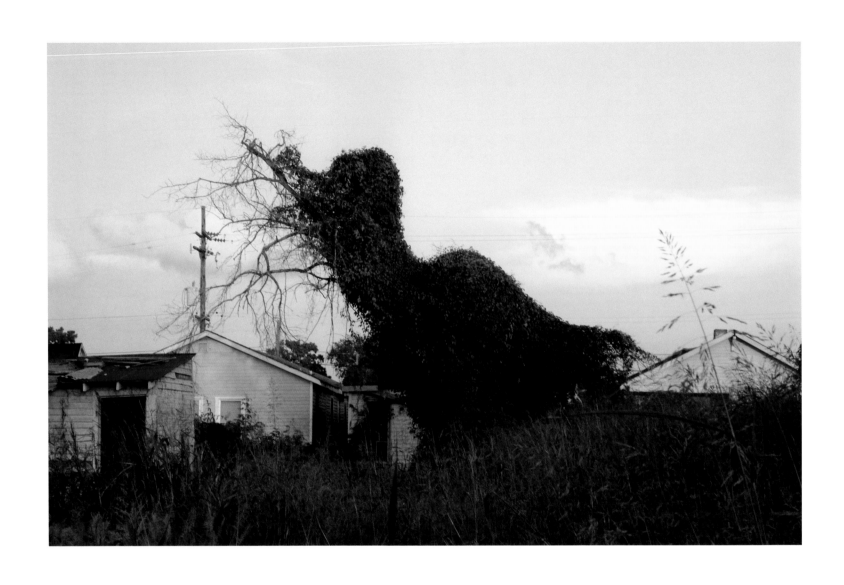

September 23, 2006.

Acknowledgments

Without the residents of the Lower Ninth Ward, whose courage and perseverance was truly inspirational, this book would have been impossible. I am indebted to the U.S. Department of Health and Human Services and to Chu Chu Saunders, Senior Deployment Manager of Westover Consultants. I am also appreciative of Megan Bronson, Toby Bourisseau, Sherry Janet Cocozza, Rashied Cormier, Karen Hawkins, Mattie Hawkins, George Scott Jakovics, Doreatha Kurtz, Lucie Labreche-Queening, Sylvia Longknife, Lynnell Morris, Cassandria Peoples, Mary C. Ragan, Robin Randall, Timothy Williams, and Elliott Hill, all members of Team #3 New Orleans. Their support allowed me to embark on this journey, and many of their stories are included in this book. A sincere thanks to Mary C. Ragan, for sharing her stories of Miss Victoria, Samantha, and the nameless woman. The generosity and leadership of Colonel Jerry Sneed was greatly appreciated by the residents and volunteers alike, as was Sergeant Duskin's hauntingly beautiful rendition of "Amazing Grace."

I owe a great debt of gratitude to Laura Fatemi, Lousie Lincon, and Chris Mack of the DePaul University Art Museum for their support, resulting in the first exhibition of this photographic work *Look and Leave: New Orleans in the Wake of Katrina.*

I thank George F. Thompson, the founder and director of the Center for American Places at Columbia College Chicago, for having the vision to transform these photographs into a book. His keen artistic eye, intelligent guidance, and shared commitment to the the importance of this work have my deepest appreciation. I am also grateful to Brandy Savarese, Jason Stauter, Ben Bilow, and David Skolkin, who worked tirelessly to bring this book into fruition. A special thank you is also extended to Joan Morgenstern, for her generous support of this project.

I am most grateful to Paul Fulton, Louise Olderman, Susan Cherry, Beth Davis, and Jocelyn Lippert, for their invaluable editing of the text. I am so appreciative of Rick and Deann Bayless, Catherine Rocca, Cynthia Raskin, Susan Oliver, Brad Temkin, Tracey Vowell, and Mark Segura, who have lent incredible support and wisdom throughout my photographic career.

I was extremely fortunate to have had three extraordinary teachers. My photography could not have blossomed without the guidance, support, and encouragement from my mentor, Dick Olderman, a man with a heart as

wide as the ocean. It is through his extraordinary view of the world that I learned the poetry of photography. Love of Louisiana's vibrant culture unfolded during the many hours spent in Breau Bridge with Debbie Flemming Caffery, whose contagious enthusiasm contributed to my numerous returns to the South. I am also grateful to Arthur Lazar, for his critical eye and unwillingness to settle for anything less than a master print.

My family has been my staunchest supporters. I wish to thank my parents, Muriel and Maurice Fulton, for a lifetime of unconditional love and support. I am so appreciative of my siblings, Peggy, Barbara and Paul, but especially to Peggy, for always being there for me with her wise counsel.

To my three children, Katie, Drew, and Valerie, whose critical eyes and opinions I so often relied on, and to my dear husband, Howard, who through the years has been my lifeline, your encouragement and continual support has sustained me, but, most importantly, you have loved me throughout.

About the Author and the Essayist

Jane Fulton Alt was born in Chicago in 1951. She grew up with parents who were avid collectors and began actively exploring the visual arts while raising her own family. Alt is a clinical social worker who has been in practice for more than thirty-five years. She received her B.A. from the University of Michigan and her M.A. from the University of Chicago and she studied art and photography at the Art Institute of Chicago, Columbia College Chicago, and the Evanston Art Center. Alt's photographs explore universal issues of humanity, reflecting her interest in the mysteries of life and the non-material world. Her photographs have been exhibited extensively nationally and internationally, and they can be found in many permanent collections, including Yale University's Beinecke Library, the New Orleans Museum of Art, the Museum of Fine Arts, Houston, De Paul University's Art Museum, the Dancing Bear collection of William Hunt, and Centro Fotografico Alvarez Bravo in Oaxaca, Mexico. Alt received the Illinois Arts Council Fellowship Award in 2007 and Ragdale Foundation fellowships in 2007 and 2008. Alt resides in Evanston, Illinois, with her husband.

Michael A. Weinstein was born in Brooklyn, New York, in 1942, and he spent his youth on Long Island. He received his B.A., summa cum laude, from New York University and his Ph.D., with honors, from Western Reserve University. Weinstein has been the photography critic for the Chicago alternative newspaper, *NewCity,* since 1990. He has written on photography for art magazines, philosophy journals, and photography catalogs and books. He has been a professor of political science at Purdue University since 1974 and has been awarded Guggenheim, Rockefeller Humanities, and Lily Foundation fellowships. The latest of his twenty-three books is *The Imaginative Prose of Oliver Wendell Holmes* (University of Missouri Press, 2006).

A NOTE FROM THE AUTHOR:

The photographs in this book were taken between November 2005 and February 2007, a time when I was in deep mourning for the residents of the Lower Ninth Ward and for our nation. I felt like a walking container for all the grief and sorrow that I absorbed while trying to support the residents as they returned to their homes. It is through this "lens" that the images were made. I photographed with a digital Canon Rebel XT.

One question that has often been asked of me is, "Why are there no people in the photographs?" As a social worker, I felt it would be unethical to intrude on the personal lives of the families as they were trying to cope with their losses. When I did decide to photograph, it was with the conscious decision to do it before or after I reported to the "Look and Leave" site, thus avoiding any ambiguity between my professional roles as a clinical social worker and a photographer. I discovered that the potency of these photographs is due, in part, to the merging of the two professions at the moment the shutter was released.

The markings on buildings during the search and rescue are informative. For example, on pages 46 and 47 one sees that the search was conducted by rescue team 3/505; on September 11, 2005 (9-11); there was no entry (NE) to the building; the building was totally full of water (TFW); and there was one adult (1A) found and no dead (0D).

A portion of the proceeds from this book will be donated to Habitat for Humanity's rebuilding efforts in New Orleans. Names in the stories were changed to protect the privacy of the residents. This photographic work began while I was under Contract No. 280-02-0204 with the United States Department of Health and Human Services SAMHSA (Substance Abuse and Mental Health Services Administration) Katrina Assistance Project. The opinions expressed are solely mine.